ROYALTY
IN "QUOTES"
A MISCELLANY OF REGAL RAMBLINGS

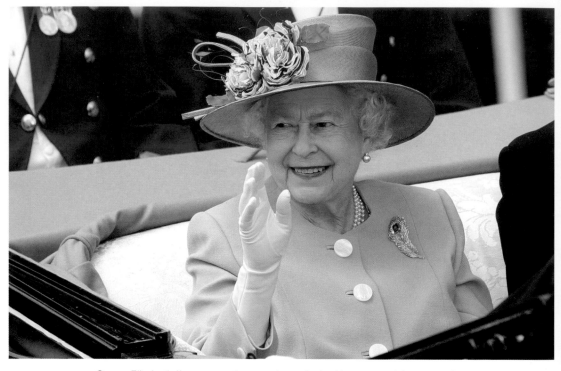

Queen Elizabeth II waves to the crowds as she is driven around the course in a
carriage on Ladies' Day at Royal Ascot.
17th June, 2010

"In tomorrow's world, we must all work together as hard as ever, if we're truly to be United Nations."

Queen Elizabeth II: Urging nations to collaborate during her
second address of the United Nations, 6th July, 2010.

ROYALTY
IN "QUOTES"

A MISCELLANY OF REGAL RAMBLINGS

AMMONITE
PRESS

First published 2012 by
Ammonite Press
an imprint of AE Publications Ltd,
166 High Street, Lewes, East Sussex, BN7 1XU

Images © Mirrorpix, 2012
Copyright © AE Publications Ltd, 2012

ISBN 978-1-90770-866-4

British Cataloguing in Publication Data. A catalogue
record of this book is available from the British Library.

Editor: Ian Penberthy
Series Editor: Richard Wiles
Picture research: Mirrorpix
Design: Robin Shields

Colour reproduction by GMC Reprographics
Printed and bound in China by 1010 Printing International Ltd

"Dontopedology is the science of opening your mouth and putting your foot in it."

Duke of Edinburgh.

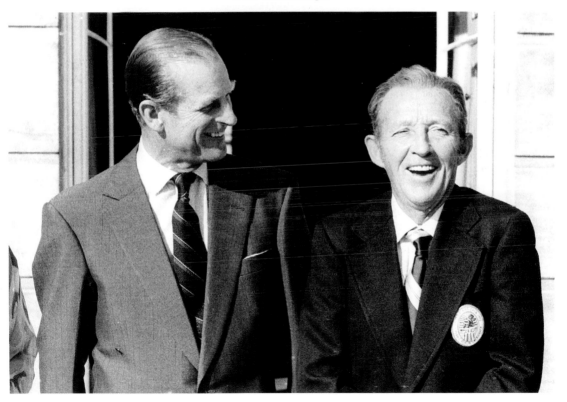

Prince Philip and Bing Crosby at Buckingham Palace.
2nd July, 1976

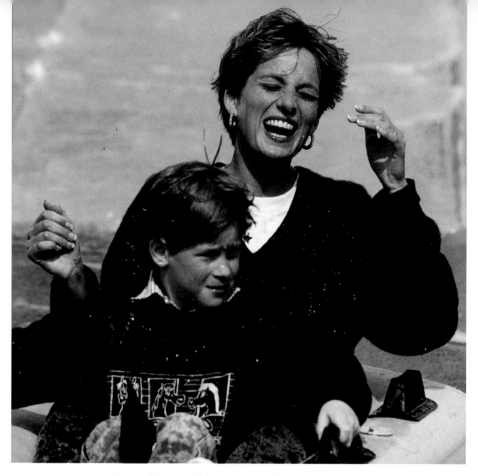

Princess Diana and Prince Harry at Thorpe Park in Surrey.
1992

"To us, just two loving children, she was quite simply the best mother in the world."

Prince Harry: During a tribute to his mother, Princess Diana, on the tenth anniversary of her death, 2007.

Introduction

Since the death of Queen Victoria in 1901, Britain's monarchs, and their families, have become increasingly less remote from the citizens of the United Kingdom and many former Empire/Commonwealth countries around the world that retain a Royal head of state, moving from being largely private, revered figureheads to take their place at the centre of today's celebrity culture, their every word and antic reported by an avaricious media.

The move into the limelight was led by Victoria's son, King Edward VII, previously the playboy Prince of Wales, whose pursuit of pleasure involved him in an adultery case. Surprisingly, though, he was a popular King, reinstating a number of Royal public ceremonies, including the State Opening of Parliament, which did much to put the monarch in touch with the people. Edward VII's son, King George V, furthered that popularity. He changed the Royal family's name to Windsor, to distance them from their Germanic roots during the First World War, made the first Royal Christmas radio broadcast and removed much of the aloofness that surrounded the Royal family. After George V, however, another playboy Prince occupied the throne, albeit for less than a year, since King Edward VIII preferred life with a divorced American socialite to his Royal duties, handing the throne to his brother, King George VI, father of our present Queen, Elizabeth II. George VI and his Queen Consort, Elizabeth (the Queen Mother), together with their two daughters, Princesses Elizabeth and Margaret, revived the monarchy's fortunes once more, being taken to the nation's heart for their refusal to move to safety and their efforts to boost morale during the Second World War, becoming symbols of national resistance. That affection has continued, more or less undimmed, throughout Queen Elizabeth II's long reign and looks set to carry on for the foreseeable future.

As the popularity of the Royals has risen, so has interest in everything they have to say. Their utterances, though, are not always tempered by regal restraint or, come to that, common sense. While many of their words can be kind, compassionate, self-deprecating, profound and amusing, they can also be arrogant, ignorant, tactless, offensive and downright batty.

Illustrated with photographs from the vast archives of Mirrorpix, this book takes a tongue-in-cheek look at the ramblings of Britain's Royals, for the purpose of critique and review, showing that they are indeed human, with the same attitudes and prejudices as the rest of us, even though they may be a little detached from reality.

"**Class can no longer stand apart from class ... I claim for music that it produces that union of feeling which I much desire to promote.**"

Edward VII: Speech when opening the Royal College of Music, 1883.

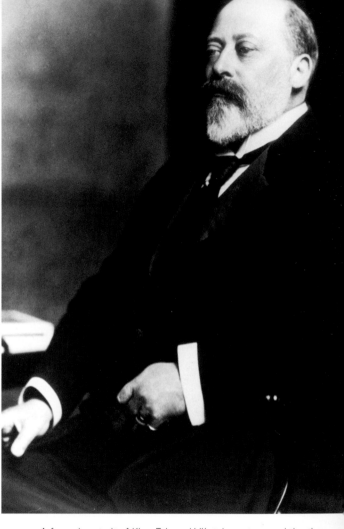

A formal portrait of King Edward VII, taken at around the time of his coronation.
c.1901

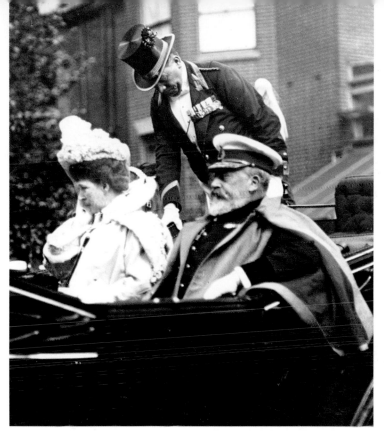

King Edward VII and Queen Alexandra on their way to the Olympia exhibition centre in London. c.1901

"Because a man has a black face and a different religion from our own, there is no reason why he should be treated as a brute."

Edward VII: Complaint to his mother (Queen Victoria) about British treatment of the indigenous population of India.

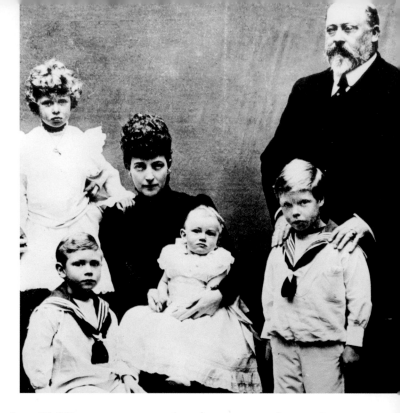

King Edward VII and Queen Alexandra with their grandchildren: (L–R) Princess Mary (the Princess Royal), Prince Albert (later King George VI), Prince Henry (Duke of Gloucester) and the Prince of Wales (later King Edward VIII). c.1906

"I cannot be indifferent to the assassination of a member of my profession. We should be obliged to shut up business if we, the Kings, were to consider the assassination of Kings as of no consequence at all."

Edward VII.

King Edward VII (second L) talking to Wilbur Wright at Le Mans, from where the American pioneer aviator made flights over southern France.
1909

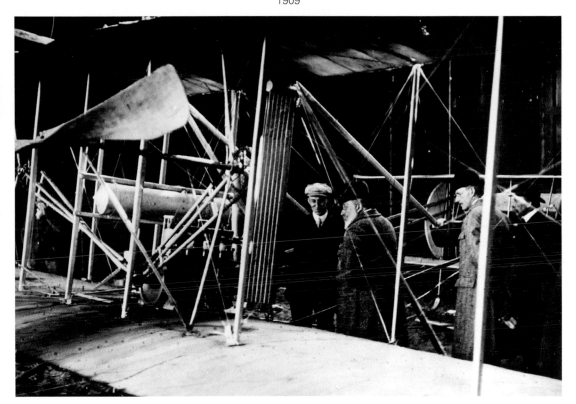

"No, I shall not give in; I shall go on; I shall work to the end."

Edward VII: While terminally ill and having suffered a number of heart attacks on the same day, 6th May, 1910.

King Edward VII lying in state at Westminster Hall, London, following his death on 6th May, 1910, at Sandringham. Despite having indulged in a wild social life during his time as Prince of Wales, the son of Queen Victoria was a popular monarch. He was the longest serving heir apparent (at 59 years, 74 days) until Prince Charles gained that distinction in April, 2011. Edward VII was interred in St George's Chapel, Windsor on 20th May, 1910.
7th May, 1910

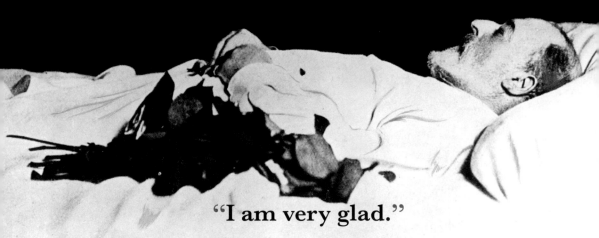

"I am very glad."

Edward VII: On being told that his horse, Witch of the Air, had won at Kempton Park that afternoon.
They were his last words. He died at 11.45pm that same day, 6th May, 1910.

"Always go to the bathroom when you have a chance."

George V.

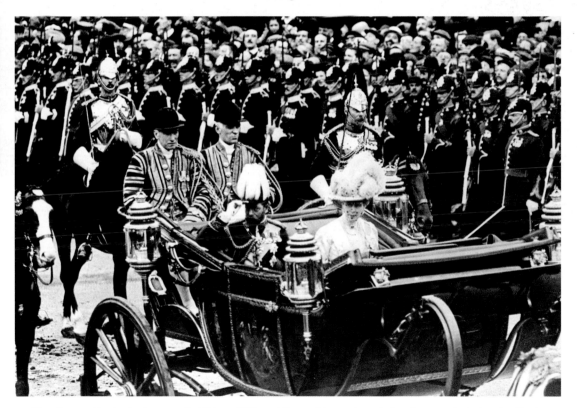

King George V, who had succeeded Edward VII, and Queen Mary acknowledge the crowds during the King's coronation procession through London.
22nd June, 1911

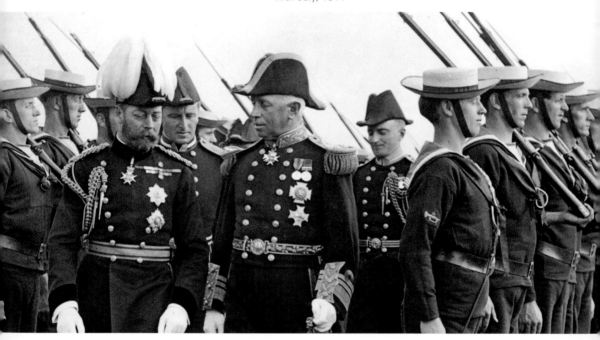

King George V (L) inspecting a naval guard of honour during a visit to Aberystwyth. The Royal party was touring Wales following the investiture of the Prince of Wales (later Edward VIII) at Caernarfon Castle.
17th July, 1911

"My father was frightened of his mother; I was frightened of my father, and I am damned well going to see to it that my children are frightened of me."

George V.

"I may be uninspiring, but I'll be damned if I'm an alien!"

George V: In response to H.G. Wells' comment that the Royal court was alien and uninspiring.

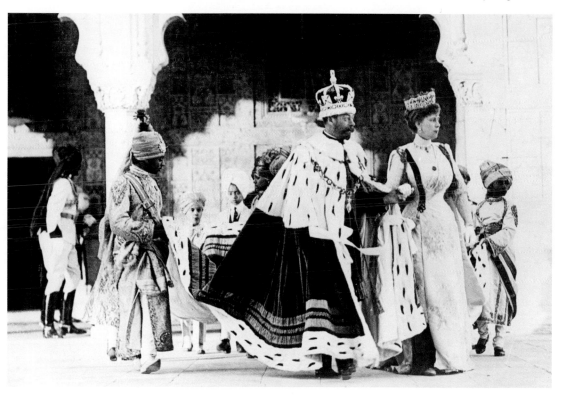

Resplendent in their regal trappings, King George V and Queen Mary prepare to attend a garden party during their visit to India to mark the King's coronation. While there, they attended the Delhi Durbar, a ceremony in which they were declared Emperor and Empress of the sub-continent.
December, 1911

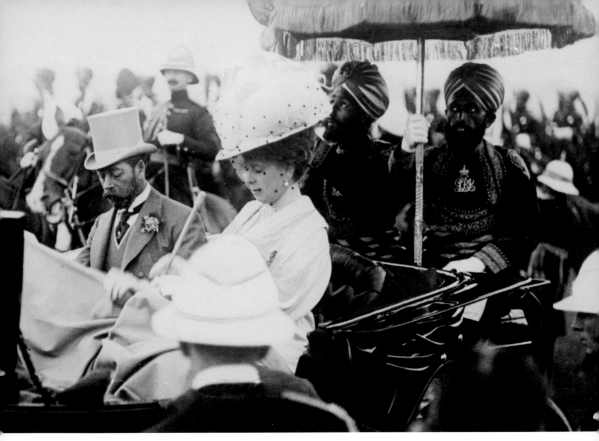

King George V and Queen Mary are driven in a carriage during a visit to Calcutta following the Delhi Durbar. December, 1911

"When I die, India will be found engraved on my heart."

Queen Mary.

"Try living on their wages before you judge them."

George V: Taking exception to the suggestion that workers involved in the General Strike were revolutionaries.

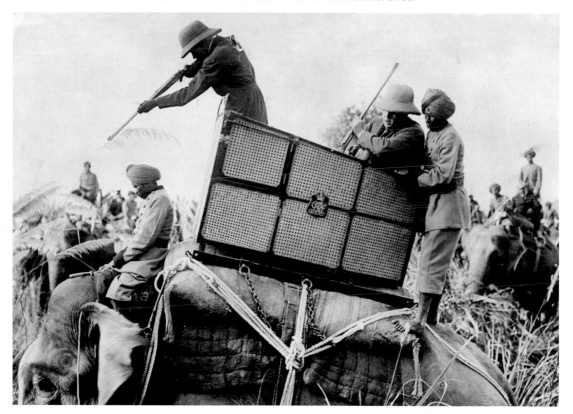

King George V (L) hunting tigers in the Nepal jungle, following his attendance at the Delhi Durbar. 15th January, 1912

Watched by throngs of bemused locals, King George V (L) reviews British troops at Calcutta.
January, 1912

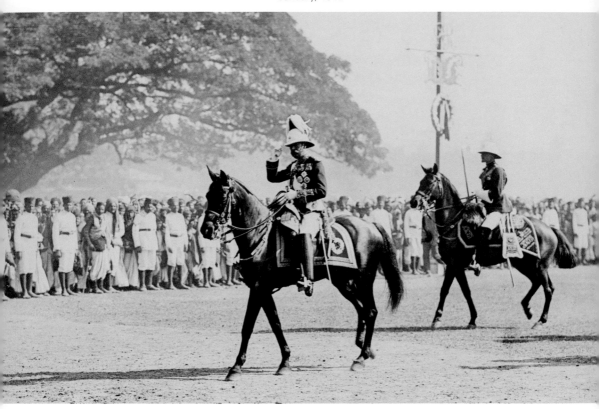

"**Golf always makes me so damned angry.**"

George V.

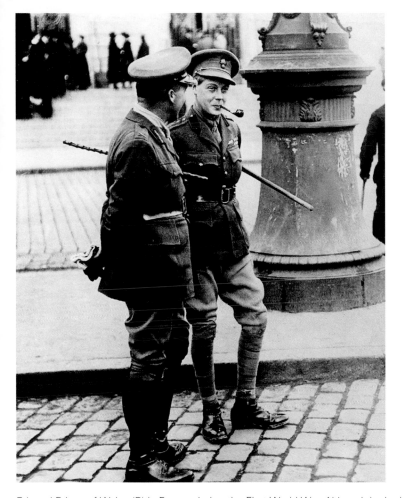

"The thing that impresses me most about America is the way parents obey their children."

Edward Prince of Wales (R) in France during the First World War. Although he had enlisted in the Grenadier Guards in 1914, he was not permitted to take part in any action for fear of the consequences should he be captured. However, he visited the men in the trenches as often as he could.
1918

"I have buried my angel, and with him my happiness."

Queen Alexandra: On the death of her eldest son, Prince Albert Victor, Duke of Clarence and Avondale, who had died of influenza in January, 1892.

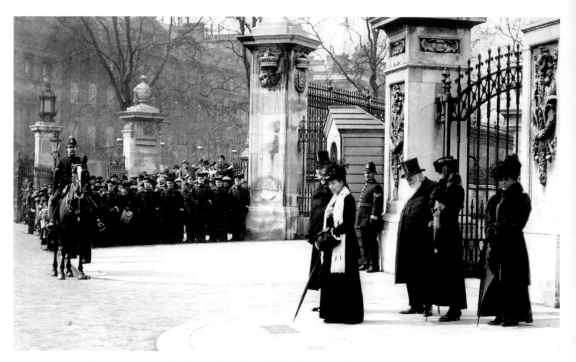

Queen Alexandra (pale scarf), widow of King Edward VII, stands outside the gates of Buckingham Palace, London, to receive the salute during a march-past of troops following the First World War.
26th April, 1919

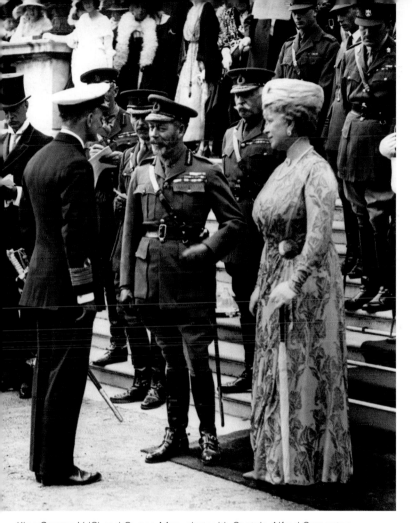

"After I am dead, the boy will ruin himself in twelve months."

George V: Referring to his son, Edward, Prince of Wales, later Edward VIII, who renounced the throne to marry twice-divorced American socialite Wallis Simpson. His reign lasted 326 days, one of the shortest in Britain's history.

King George V (C) and Queen Mary chat with Captain Alfred Carpenter VC of the Royal Navy during a garden party held in honour of holders of the Victoria Cross, Britain's highest award for gallantry.
5th July, 1920

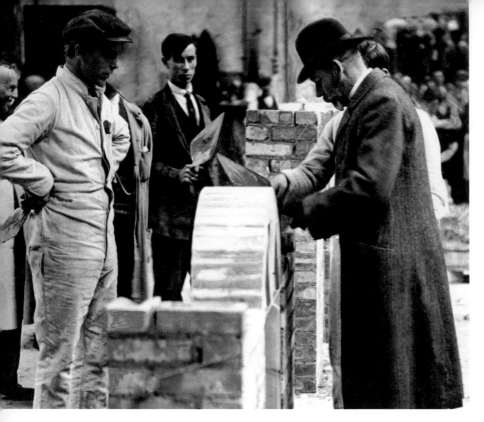

King George V (R) tries his hand at laying bricks during a visit to the Government Instructional Factory for ex-servicemen in Cricklewood, north London.
7th June, 1920

> "I pray to God my eldest son will never marry and have children, and that nothing will come between Bertie and Lilibet and the throne."

George V: A reference to Prince Albert, Duke of York and his daughter, Elizabeth. Albert became King George VI upon the abdication of his brother, Edward VIII, in 1936, while Princess Elizabeth inherited the throne in 1952.

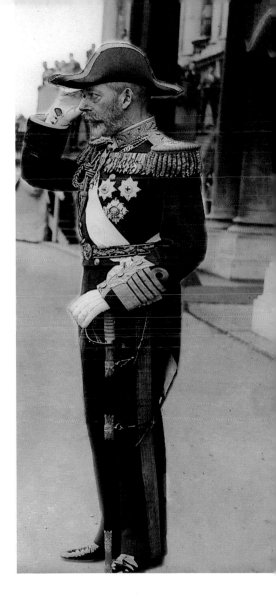

"I have many times asked myself whether there can be more potent advocates of peace upon earth through the years to come than this massed multitude of silent witnesses to the desolation of war."

George V: Speech at Terlincthun British Cemetery, Boulogne, France, 13th May, 1922. At the time, the cemetery contained the graves of over 3,300 British casualties of the First World War.

King George V in ceremonial dress to open the Northern Ireland Parliament in Belfast. 23rd June, 1921

"I cannot understand it; after all, I am only a very ordinary sort of fellow."

George V: Comment on the adulation expressed by cheering crowds at his Silver Jubilee in 1935.

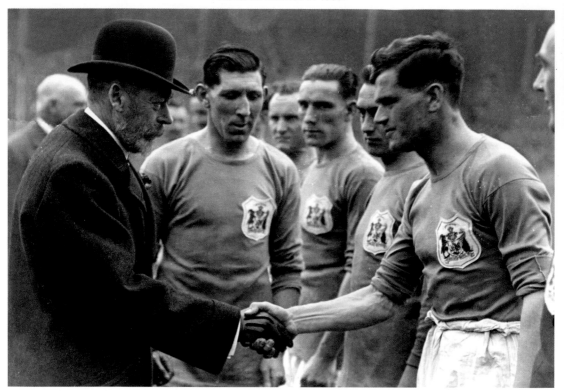

King George V, watched by Cardiff City captain Fred Keenor (C), shakes hands with George McLachlan. Other City players visible (from L) are Hughie Ferguson, Jimmy Nelson, Tom Watson, George McLachlan and Tom Farquharson. The team was playing Arsenal in the FA Cup Final at Wembley.
23rd April, 1927

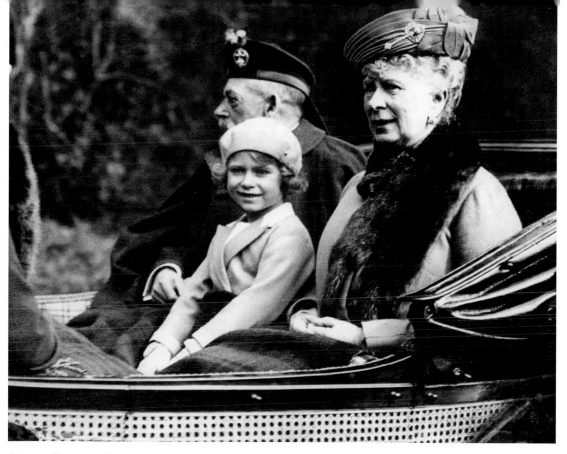

Princess Elizabeth sitting in a horse-drawn carriage with her grandparents, King George V and Queen Mary, on their way back to Balmoral after attending church at nearby Crathie.
5th September, 1932

"There's only one thing I never did and wish I had done: climbed over a fence."

Queen Mary.

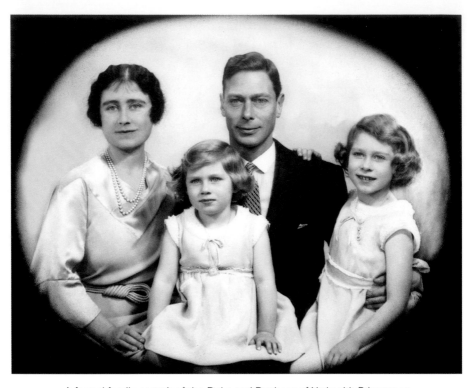

A formal family portrait of the Duke and Duchess of York with Princesses Elizabeth (R) and Margaret before the Duke became King George VI upon the abdication of his brother, Edward VIII.
c.1933

"He was such a wonderful person, the very heart and centre of our happy family."

Princess Margaret: Referring to her father, King George VI, following his death in 1952.

"I wanted to be an up-to-date king, but I didn't have much time."

Edward VIII: As Duke of Windsor following his abdication.

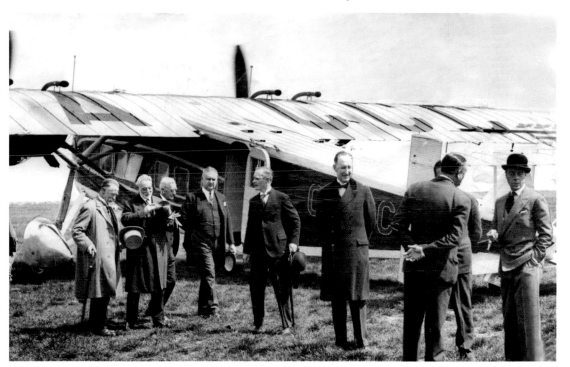

Edward, Prince of Wales (R) is greeted by local dignitaries on alighting from his aircraft at Cardiff Municipal Airport. The machine, a Vickers Viastra, had been built specifically for the Prince as a Royal transport. He was the first member of the Royal family to learn to fly and was instrumental in setting up the Royal Flight. 16th May, 1933

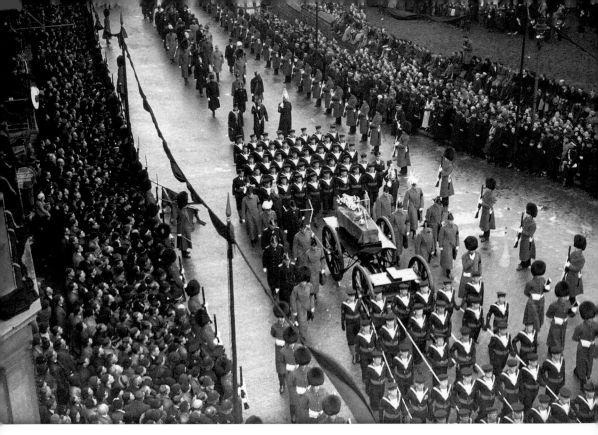

The coffin of King George V is carried on a gun carriage pulled by 124 naval ratings from Westminster Hall, London, where his body had lain in state, to Paddington Station for its final journey to Windsor, where the King would be interred in St George's Chapel. He had died on 20th January.
28th January, 1936

"How is the Empire?"

George V: To his secretary while on his deathbed, January, 1936.

"When I told her what happened, I broke down and sobbed like a child."

George VI: Diary entry referring to the moment that he told his mother, Queen Mary, that he was to become King following the abdication of his brother, King Edward VIII.

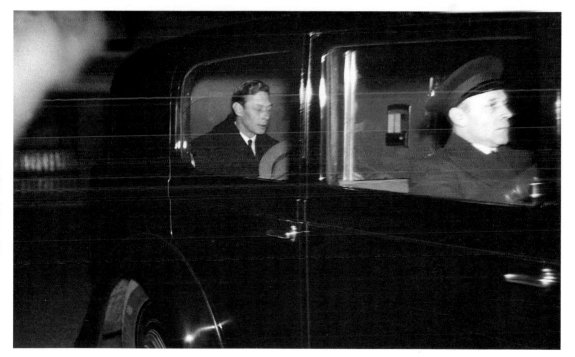

A visibly strained Duke of York, soon to be King George VI, is driven from Buckingham Palace during the abdication crisis surrounding his brother, King Edward VIII. Edward renounced the throne to be able to marry twice-divorced American socialite Wallis Simpson.
December, 1936

King George VI (R) with his family on the balcony of Buckingham Palace following his coronation. L–R: Queen Elizabeth the Queen Consort, Princess Elizabeth, Queen Mary, Princess Margaret.
12th May,1937

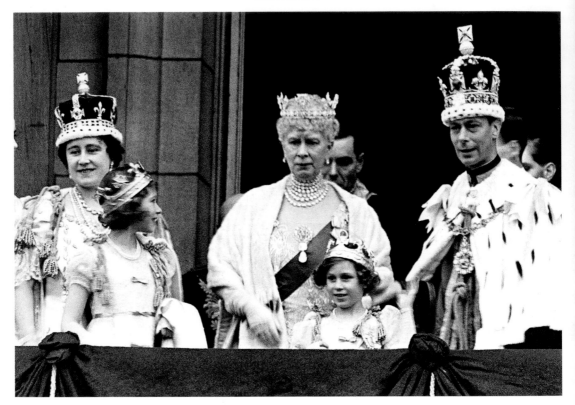

"The highest of distinctions is service to others."

George VI.

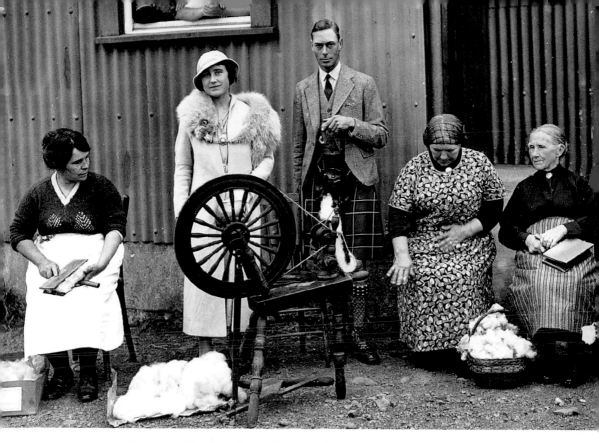

King George VI and his Queen, Elizabeth, visit Scottish wool spinners.
1937

"Those last days were like sitting on the edge of a volcano."

Queen Elizabeth the Queen Mother: On the abdication of King Edward VIII, which led to her husband, Albert, Duke of York, becoming King George VI.

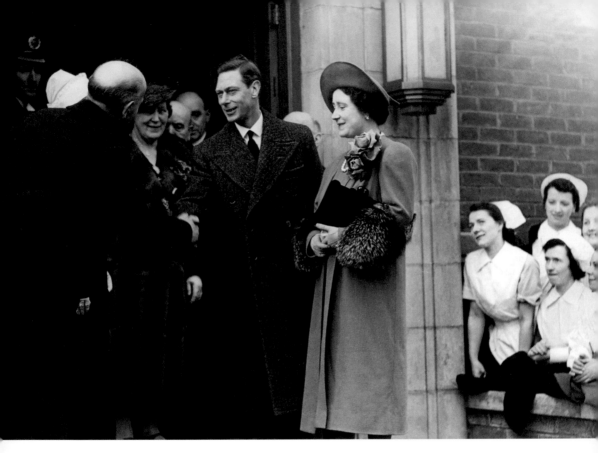

King George VI and Queen Elizabeth visit Newcastle General Hospital.
22nd February, 1939

"The lowest of the low."

Queen Elizabeth the Queen Mother: On twice-divorced American socialite
Mrs Wallis Simpson, for whom Edward VIII renounced the throne.

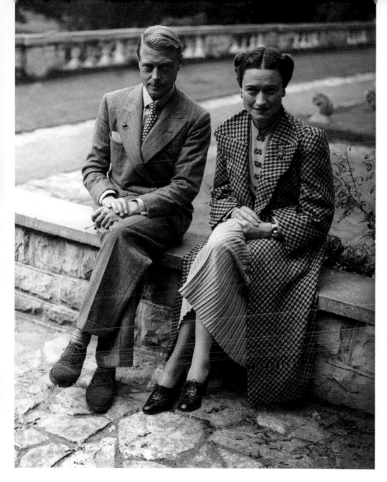

"I have found
it impossible
to carry the
heavy burden of
responsibility and
to discharge my
duties as King as
I would wish to do
without the help
and support of the
woman I love."

Edward VIII: Abdication
broadcast, 11th December, 1936.

Following his abdication, Edward VIII was given the title Duke of Windsor, and after he married Wallis Simpson in 1937, the couple settled in France. The Duke and Duchess are seen here upon their return to England following the outbreak of the Second World War. It was widely suspected that they held Nazi sympathies, and Prime Minister Winston Churchill arranged for them to be sent to the Bahamas, where he felt they could do no harm.
15th September, 1939

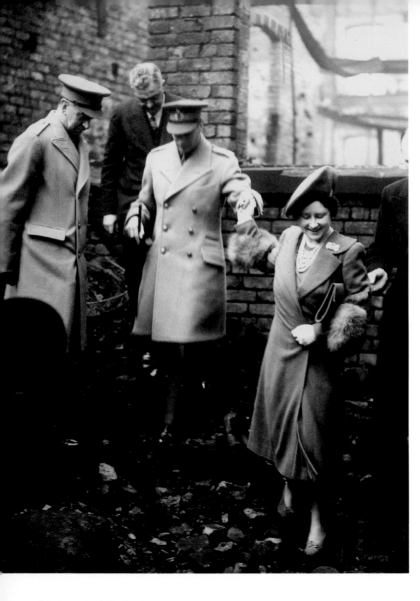

"I'm glad we've been bombed. It makes me feel I can look the East End in the face."

Queen Elizabeth the Queen Mother: After two German bombs had exploded in the courtyard of Buckingham Palace during the Second World War.

King George VI and Queen Elizabeth pick their way through the rubble on a visit to a bomb damaged part of London. c.1940

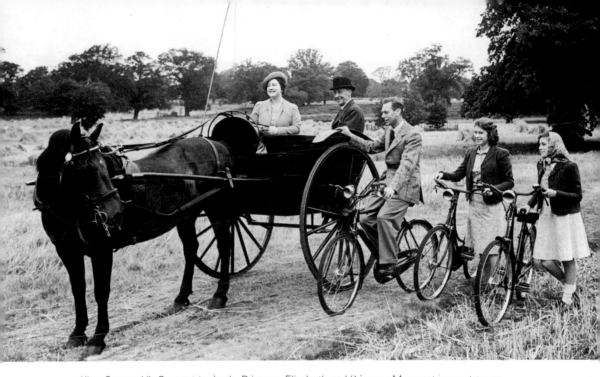

King George VI, Queen Elizabeth, Princess Elizabeth and Princess Margaret inspect crops on the Sandringham estate in Norfolk during the Second World War. To avoid using valuable petrol, they have employed a pony and trap and bicycles.
13th August, 1943.

"The children won't leave without me. I won't leave without the King, and the King will never leave."

Queen Elizabeth the Queen Mother: On the proposed evacuation of Princesses Elizabeth and Margaret to the safety of Canada during the Second World War.

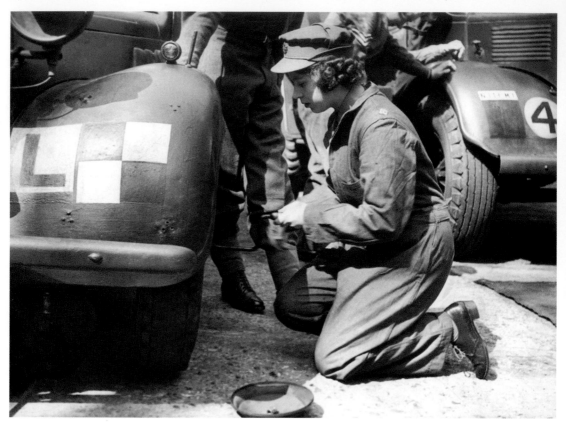

Princess Elizabeth learning basic car maintenance as a second subaltern in the Auxiliary Territorial Service (ATS), the women's branch of the British Army, during the Second World War.
12th April, 1945

"It's all to do with the training: you can do a lot if you're properly trained."

Queen Elizabeth II.

"I understand. We feel very much the same in Scotland."

Queen Elizabeth the Queen Mother: On Boer anti-British sentiment in South Africa.

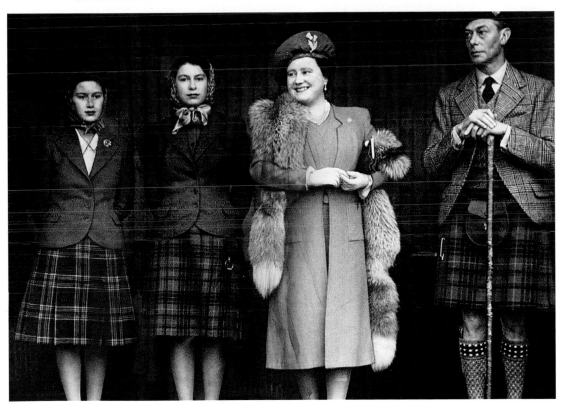

King George VI, Queen Elizabeth, Princess Elizabeth and Princess Margaret
in Scotland for the Braemar Games.
6th September, 1946

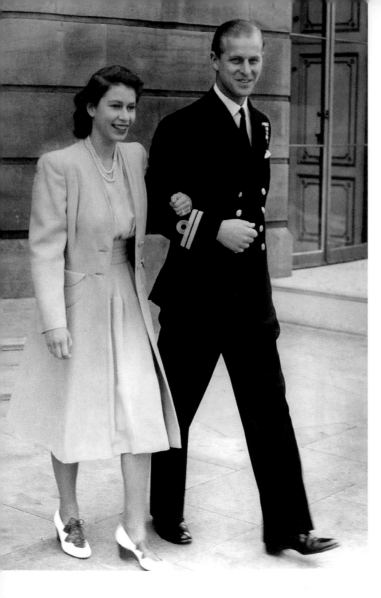

"He has, quite simply, been my strength and stay all these years. I, and his whole family, and this and many other countries, owe him a debt greater than he would ever claim, or we shall ever know."

Queen Elizabeth II: A personal tribute to Prince Philip made during a speech to mark their 50th wedding anniversary, 1997.

Princess Elizabeth and her fiancé Lieutenant Philip Mountbatten stroll arm in arm at Buckingham Palace after announcing their engagement.
10th July, 1947

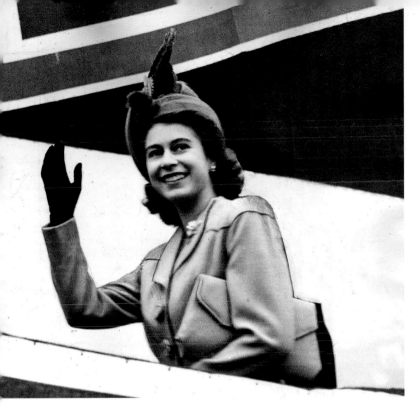

Princess Elizabeth waves to the crowds after launching the Cunard cruise liner *Caronia* on Clydebank in Scotland. 30th October, 1947

"I declare before you all that my whole life, whether it be long or short, shall be devoted to your service and the service of our great imperial family to which we all belong."

Queen Elizabeth II: As Princess Elizabeth, on her 21st birthday, 21st April, 1947.

"It is as Queen of Canada that I am here. Queen of Canada and all Canadians, not just one or two ancestral strains."

Queen Elizabeth II: During a visit to Canada.

Princess Elizabeth and the Duke of Edinburgh enjoy the fun of a square dance at Rideau Hall, the official residence of the Governor General of Canada, in Ottawa, Ontario. The couple were on a tour of the country. 1951

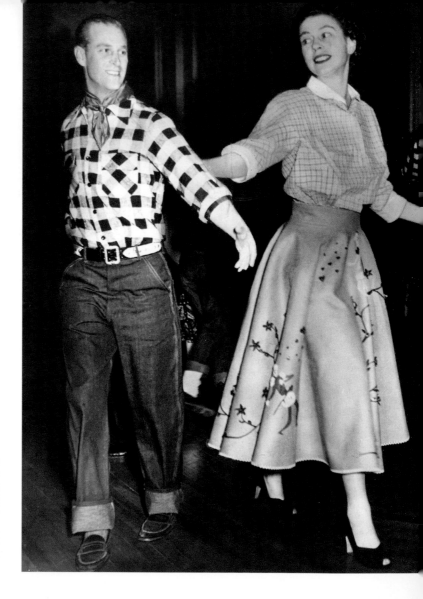

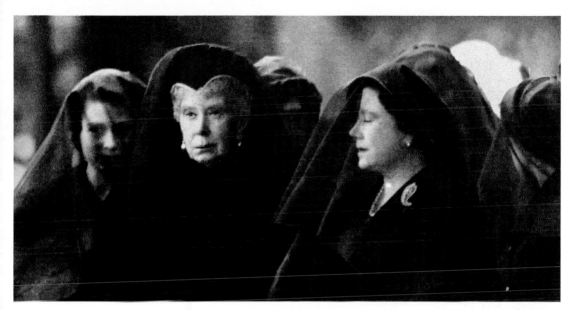

L–R: Queen Elizabeth II, Queen Mary and Queen Elizabeth the Queen Mother watch as the coffin of King George VI is carried from Westminster Abbey in London, where his body had lain in state, to make its journey to St George's Chapel, Windsor for the funeral. The King had died on 6th February, 1952 at Sandringham in Norfolk. He was the third of Queen Mary's sons to die, and his death led to the accession of Queen Elizabeth II, his daughter. 15th February, 1952

"How small and selfish is sorrow. But it bangs one about until one is senseless."

Queen Elizabeth the Queen Mother: In a letter to Edith Sitwell, shortly after the death of her husband, King George VI.

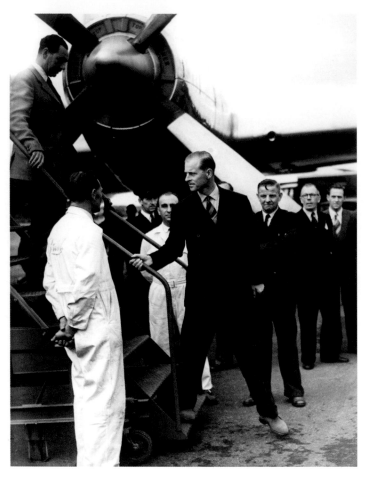

"I must be the only person in Britain glad to see the back of that plane."

Duke of Edinburgh: Referring to the retirement from service of Concorde, the noise of which he hated when it flew over Buckingham Palace, 2002.

The Duke of Edinburgh completes his tour of Britain's latest airliner at the Farnborough air show in Hampshire. He began taking flying lessons in the same year and by the age of 70 had accrued over 5,000 hours as a pilot.
September, 1952

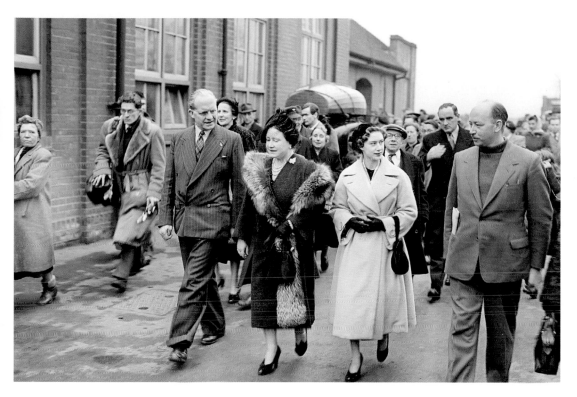

Queen Elizabeth the Queen Mother and Princess Margaret visit flood victims in Bentfleet, Essex. The North Sea flood of 1953 was one of the most devastating natural disasters to strike the UK, affecting over 1,600km of the east coast, damaging 24,000 properties and forcing 30,000 people from their homes. Over 500 people lost their lives on land and at sea.
3rd February, 1953

"Cowards falter, but danger is often overcome by those who nobly dare."

Queen Elizabeth the Queen Mother.

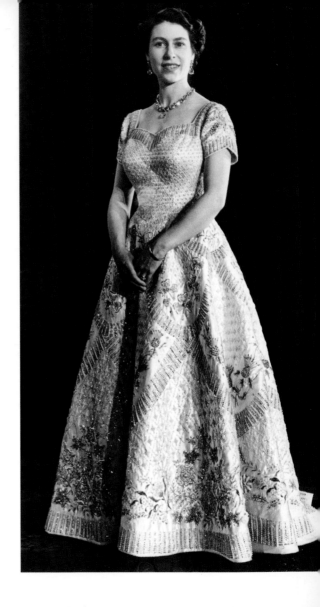

"Therefore I am sure that this, my coronation, is not the symbol of a power and a splendour that are gone, but a declaration of our hopes for the future, and for the years I may, by God's grace and mercy, be given to reign and serve you as your Queen."

Queen Elizabeth II:
Coronation speech, 1953.

An official portrait of Queen Elizabeth II to mark her coronation in 1953.
12th March, 1953

> "It was inevitable: when there are two sisters and one is the Queen, who must be the source of honour and all that is good, while the other must be the focus of the most creative malice, the evil sister."

Princess Margaret: To Gore Vidal concerning her public notoriety.

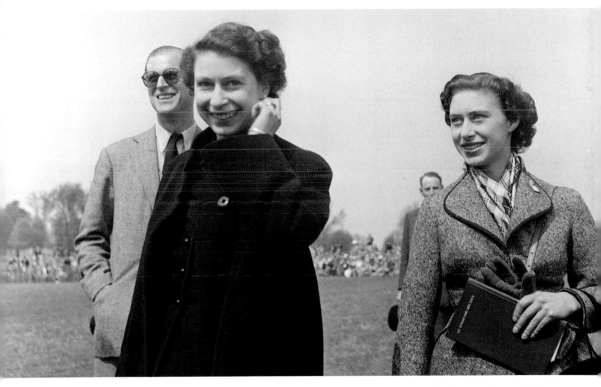

Queen Elizabeth II, the Duke of Edinburgh and Princess Margaret in relaxed mood at Badminton Horse Trials in Gloucestershire. In the following month, the Queen would attend her coronation.
12th May, 1953

Queen Elizabeth II makes her Christmas Day broadcast from Government House in Auckland, New Zealand. She and her husband, the Duke of Edinburgh, were on a tour of the country; it was the first time that a reigning monarch had visited the islands.
25th December, 1953

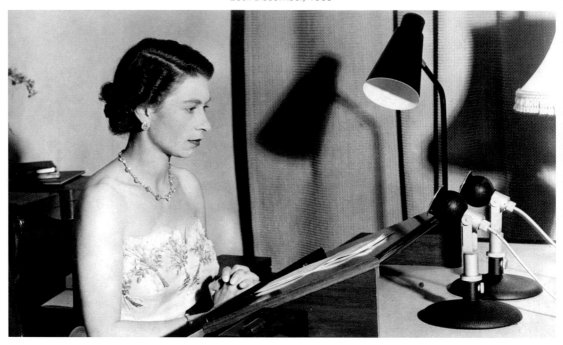

"I have been aware all the time that my peoples, spread far and wide throughout every continent and ocean in the world, were united to support me in the task to which I have now been dedicated with such solemnity."

Queen Elizabeth II: Coronation speech, 1953.

"I suppose, I'll now be known as Charley's Aunt."

Princess Margaret: On the birth of her nephew, Prince Charles.

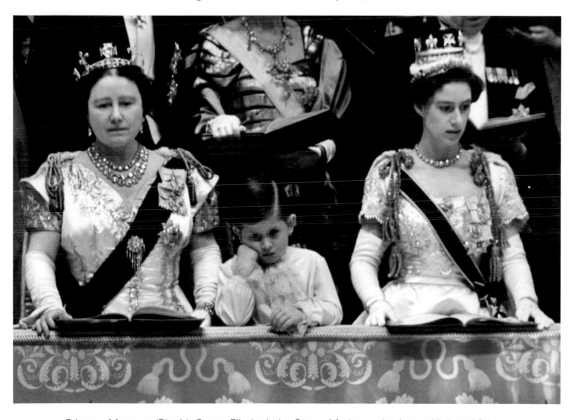

Princess Margaret (R) with Queen Elizabeth the Queen Mother and a thoroughly bored Prince Charles watch the coronation of Queen Elizabeth at Westminster Abbey in London.
2nd June, 1953

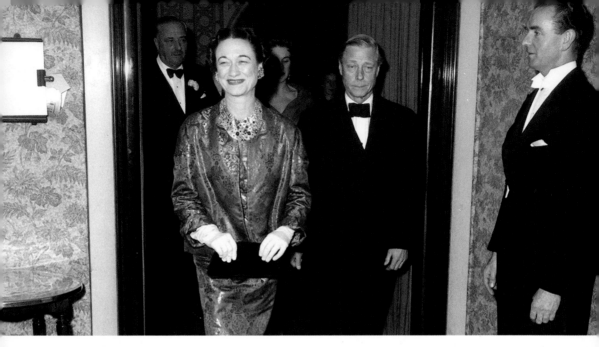

The Duke of Windsor (second R) and Duchess of Windsor arrive at party in 1953. Following the Second World War, the couple returned to France from the Bahamas, where the Duke had spent the war as governor. The French government provided them with a house in Paris at a nominal rent and waived any need to pay income tax, while the couple also benefited from being able to purchase items duty free at the British embassy.
2nd December, 1953

"Of course, I do have a slight advantage over the rest of you. It helps in a pinch to be able to remind your bride that you gave up a throne for her."

Edward VIII: As Duke of Windsor following his abdication.

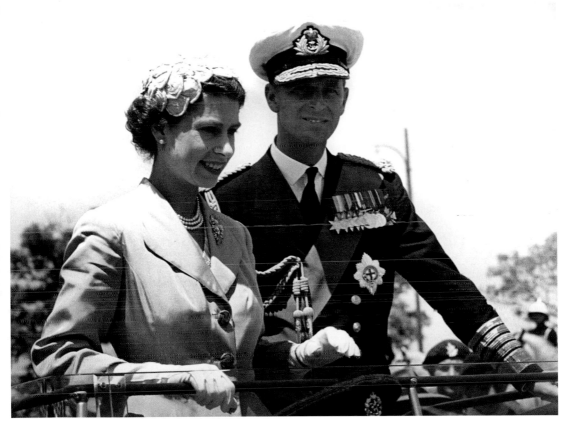

Queen Elizabeth II and her husband, Prince Philip the Duke of Edinburgh, are all smiles as they tour Gibraltar, their last port of call on a Mediterranean tour.
11th May, 1954

"Constitutionally I don't exist."

Duke of Edinburgh: Quoted in 'Should the Royals have real jobs?', BBC News, 27th January, 2011.

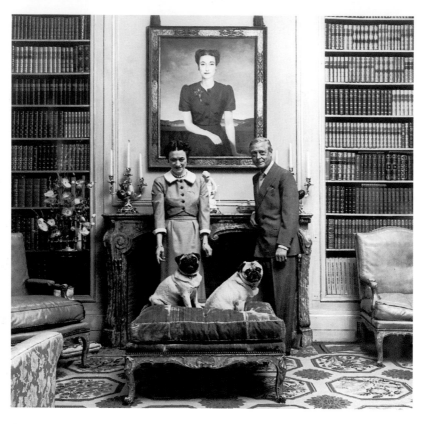

The Duke and Duchess of Windsor with their pug dogs, Trooper and Disraeli, at their home in Paris. Wallis doted on her pugs and had a succession of them.
26th July, 1955

"When you're bored with yourself, marry and be bored with someone else."

Edward VIII: As Duke of Windsor following his abdication.

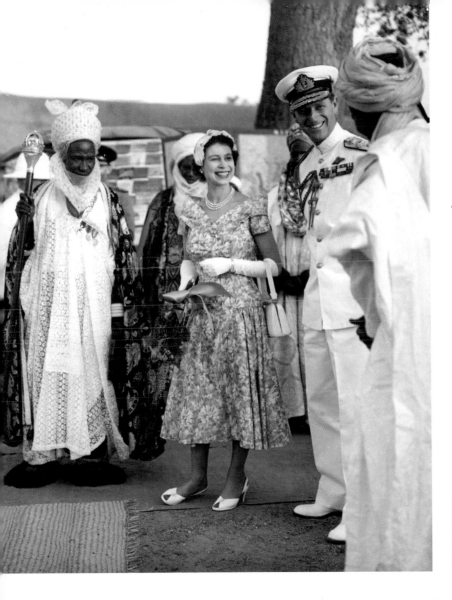

"You look like you're ready for bed!"

Duke of Edinburgh:
To the President
of Nigeria, dressed in
traditional robes.

Queen Elizabeth II and
Prince Philip, Duke of
Edinburgh meet the Emir
of Kano during a Royal
visit to Nigeria.
16th February, 1956

"All money nowadays seems to be produced with a natural homing instinct for the Treasury."

Duke of Edinburgh:
Speaking about the rate
of British tax, 1963.

Prince Philip, Duke of
Edinburgh (L) shares a joke
with the Archbishop of
Canterbury, Geoffrey Fisher
(C), prior to a concert in aid
of the Duke's award scheme
for Initiative in Youth.
1956

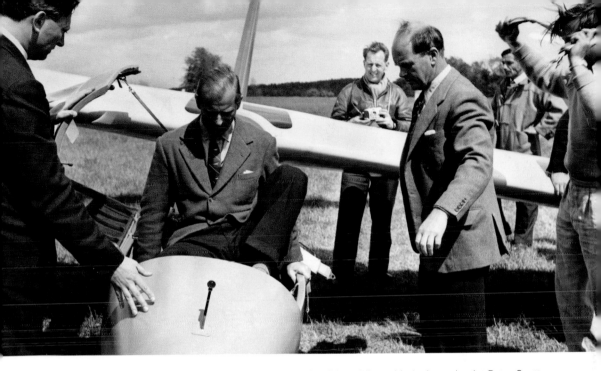

Prince Philip, Duke of Edinburgh climbs into the cockpit of a glider while ornithologist and artist Peter Scott (second R) looks on. Scott, the son of polar explorer Robert Scott, had taken up gliding the year before and was instrumental in introducing the Duke to the sport. He went on to become British gliding champion in 1963.
16th May, 1957

"If you travel as much as we do, you appreciate the improvements in aircraft design of less noise and more comfort, provided you don't travel in something called economy class, which sounds ghastly."

Duke of Edinburgh: To the Aircraft Research
Association, 2002.

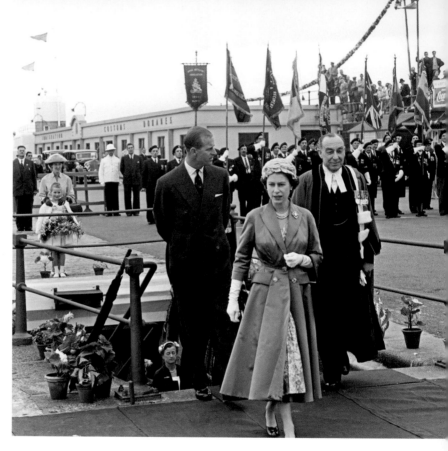

Queen Elizabeth II and the Duke of Edinburgh arrive at Albert Pier on Jersey during a Royal tour of the Channel Islands. 30th July, 1957

"I cannot lead you into battle. I do not give you laws or administer justice, but I can do something else – I can give my heart and my devotion to these old islands and to all the peoples of our brotherhood of nations."

Queen Elizabeth II: Christmas address, 1957.

"I learned the way a monkey learns: by watching its parents."

Prince Charles.

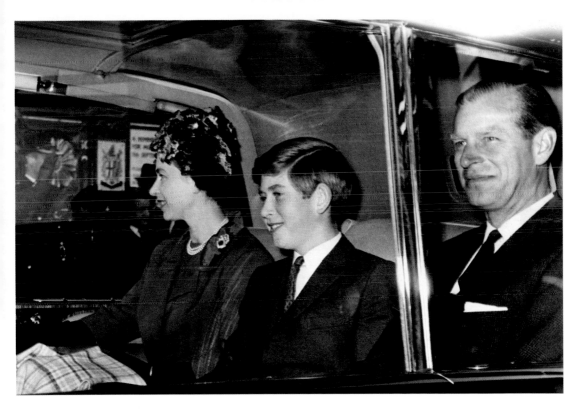

Prince Charles, the Prince of Wales, with his parents, Queen Elizabeth II and Prince Philip, Duke of Edinburgh, leave Euston Station for Buckingham Palace after travelling overnight from Aberdeen.
25th September, 1961

"I've never been noticeably reticent about talking on subjects about which I know nothing."

Duke of Edinburgh:
To a group of
industrialists in 1961.

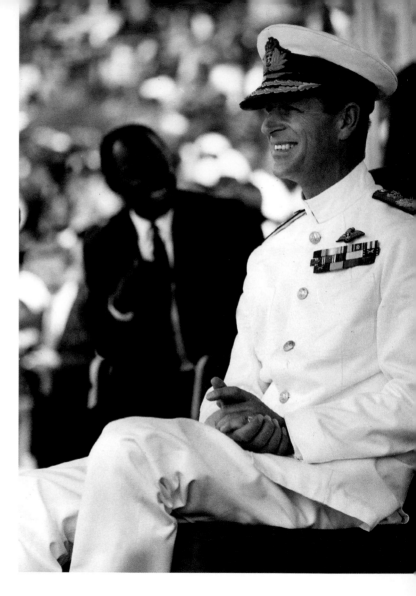

The Duke of Edinburgh
at Takoradi during a Royal
tour of the former British
colony of Ghana in Africa.
23rd November, 1961

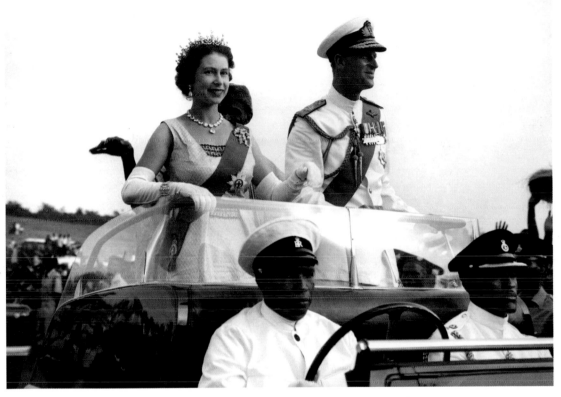

Queen Elizabeth and the Duke of Edinburgh during a Royal tour of Sierra Leone.
December 1961

"I have in sincerity pledged myself to your service, as so many of you are pledged to mine. Throughout all my life and with all my heart I shall strive to be worthy of your trust."

Queen Elizabeth II: Coronation
speech, 1953.

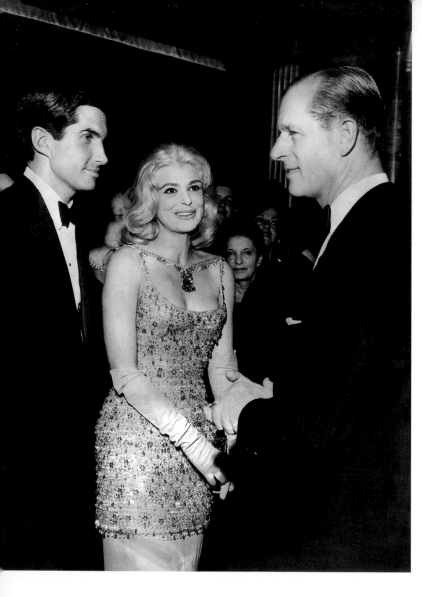

"**What about Tom Jones? He's made a million and he's a bloody awful singer.**"

Duke of Edinburgh:
On the difficulty of
becoming rich in Britain.

Prince Philip the Duke of
Edinburgh (R) meets some of the
stars of the film *The Victors* at the
film's premiere: American George
Hamilton (L) and Greek actress
Melina Mercouri.
18th November, 1963

"Aren't most of you descended from pirates?"

Duke of Edinburgh: Said in 1994 to an inhabitant of the Cayman Islands and quoted in 'Long line of princely gaffes', BBC News, 1st March, 2002.

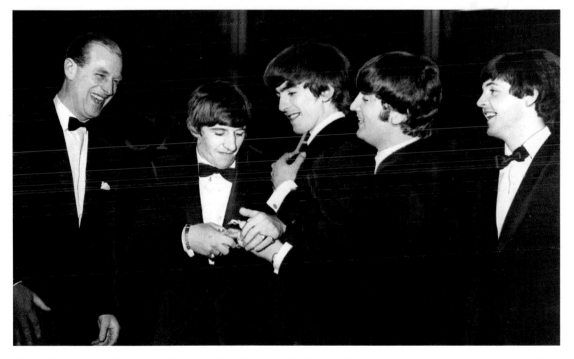

Prince Philip, Duke of Edinburgh (L), meets The Beatles – (L–R) Ringo Starr, George Harrison, John Lennon and Paul McCartney – at the Empire Ballroom, Leicester Square in London for the Carl Alan Awards for contributors to the dance and theatre industry.
23rd March, 1964

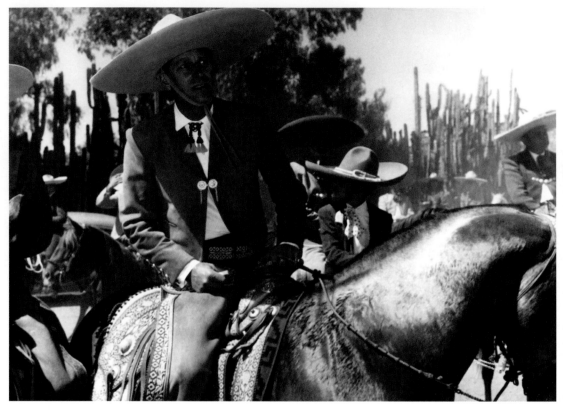

During a tour of Central America, the Duke of Edinburgh dons cowboy gear
for a visit to a Mexican cattle ranch.
28th October, 1964

"The only active sport I will follow is polo – and most of the work is done by the pony."

Duke of Edinburgh.

"I'm no angel, but I'm no Bo-Beep either."

Princess Margaret.

Princess Margaret (second R) with (L–R) Peter Sellers, her husband Tony Armstrong-Jones (the Earl of Snowdon) and Sellers' wife, actress Britt Ekland after celebrating the Queen's 39th birthday.
22nd April, 1965

"Well, you'll never fly in it, you're too fat to be an astronaut."

Duke of Edinburgh: Said at the University of Salford to a 13-year-old aspiring astronaut, whose dream was to fly NASA's Nova rocket, quoted in 'Gift of the gaffe: Prince Philip's top ten embarrassing moments', in *The Daily Mirror*, 14th December, 2009.

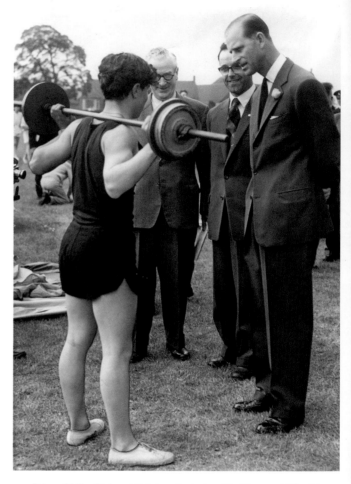

Prince Philip, Duke of Edinburgh chats with 15-year-old David Lamplough after the boy had given a demonstration of weight lifting at Brierton Modern School, West Hartlepool. 1965

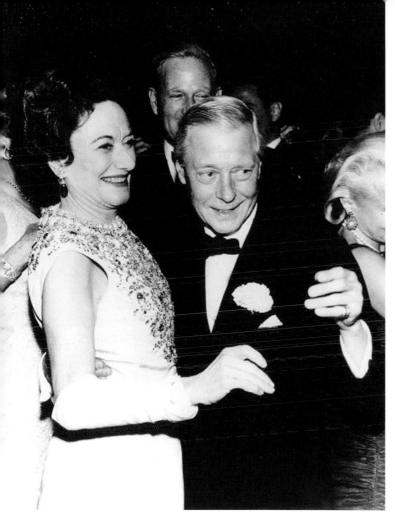

With nothing else to do, the Duke and Duchess of Windsor took on the role of minor celebrities during the 1950s and 1960s, their life a round of parties and dinners, shuttling between Paris and New York.
8th June, 1966

"You can never be too rich or too

Wallis, Duchess of Windsor.

"Ah, so this is feminist corner then."

Duke of Edinburgh:
To a group of
female Labour MPs
at a Buckingham
Palace drinks party,
2000.

The Duke Of
Edinburgh samples
a perfect example
of the cake-makers
art during a visit to
Manchester.
13th June, 1966

Captain Bobby Moore (C) presents the England team to Queen Elizabeth II prior to their opening qualifying match against Uruguay in the 1966 World Cup.
11th July, 1966

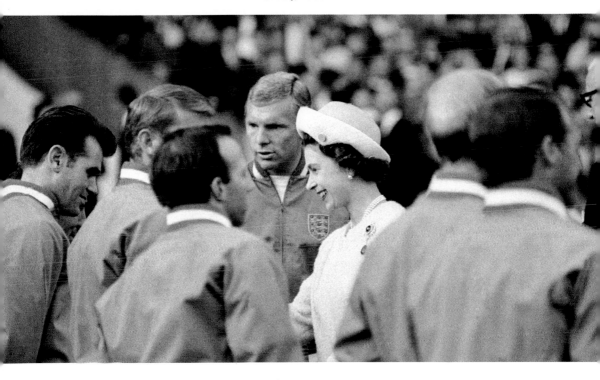

"Football's a difficult business and aren't they prima donnas?"

Queen Elizabeth II: Giving her opinion to Premier League Chairman Sir David Richards, quoted in BBC News, 2nd January, 2007.

The Duke of Windsor watches the 1966 World Cup Final at his country retreat near Paris.
30th July, 1966

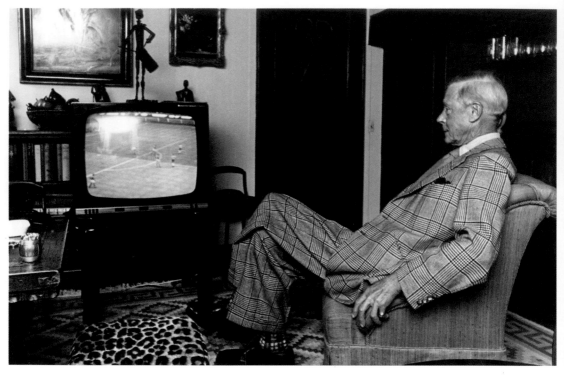

"Perhaps one of the only positive pieces of advice that I was ever given was that supplied by an old courtier, who observed: Only two rules really count. Never miss an opportunity to relieve yourself; never miss a chance to sit down and rest your feet."

Edward VIII: As Duke of Windsor following his abdication.

"Do you mean the ones in my garden or at my table?"

Wallis, Duchess of Windsor: In reply to a guest expressing admiration for a display of pansies.

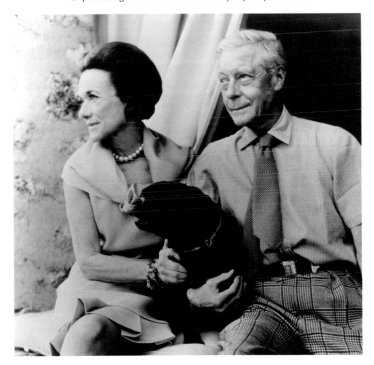

The Duke and Duchess of Windsor at their country home, Le Moulin de la Tuilerie, near Paris. The property was actually owned by the couple, and it was there that the Duke became an enthusiastic gardener, often to be seen in muddy trousers and a crumpled jacket – quite a change from his normal dapper appearance.
30th July, 1966

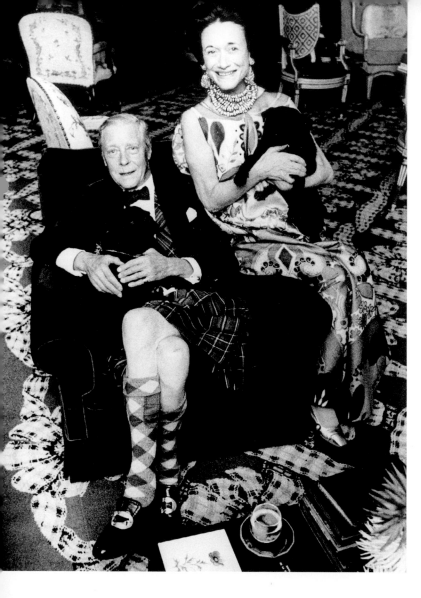

> **"I'm nothing to look at, so the only thing I can do is dress better than anyone else."**
>
> Wallis, Duchess of Windsor.

The Royal family has long had a love of the kilt and tartan, most notably when visiting Scotland, and the Duke of Windsor was no exception. He and the Duchess are shown ready to party with their ever-present pugs. 1966

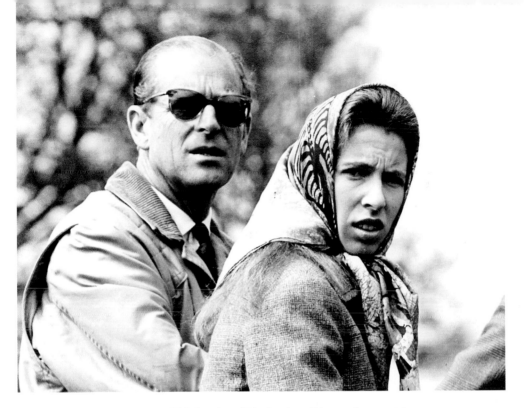

The Duke of Edinburgh and his daughter, Princess Anne watch
the action at the Badminton Horse Trials.
16th April, 1972

"If it doesn't fart or eat hay, then she isn't interested."

Duke of Edinburgh: Speaking
about Princess Anne.

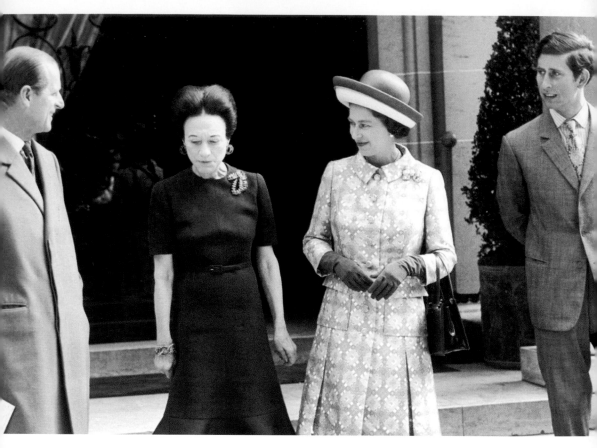

Queen Elizabeth II, the Duke of Edinburgh and Prince Charles in France with the
Duchess of Windsor. The Duke of Windsor had died two days before.
30th May, 1972

"Never explain, never complain."

Wallis, Duchess of York.

"I hate this country. I shall hate it to my grave."

Wallis, Duchess of Windsor: To the Duke of Windsor during a visit to London
in 1951.

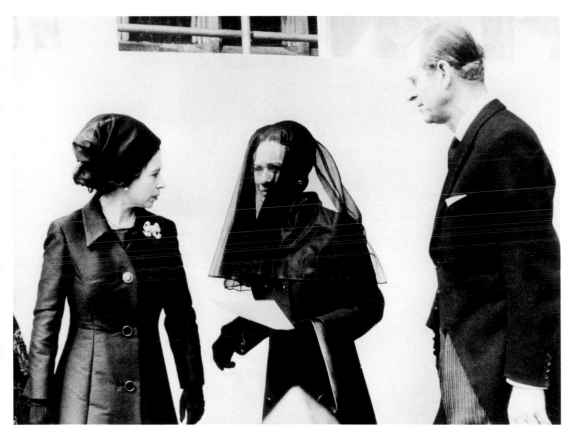

Queen Elizabeth II and the Duke of Edinburgh with the Duchess of Windsor at Windsor Castle for the funeral of the
Duke of Windsor, formerly King Edward VIII.
5th June, 1972

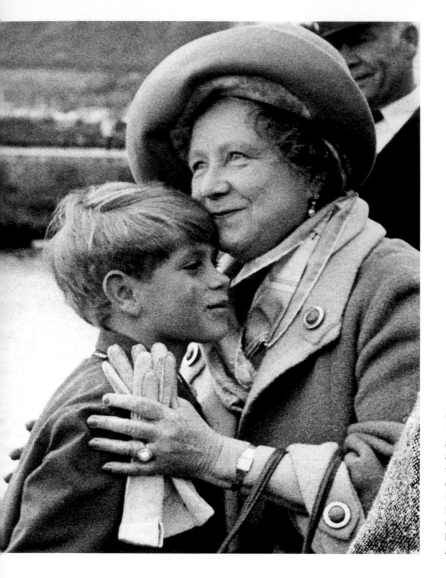

"These wretched babies don't come until they are ready."

Queen Elizabeth the Queen Mother.

Queen Elizabeth the Queen Mother greets Prince Edward, at the Scottish port of Scrabster after he had come ashore from the Royal Yacht *Britannia* with other members of the Royal Family to travel to the Queen Mother's Highland home, Mey Castle, for a belated 72nd birthday celebration.
August 1972

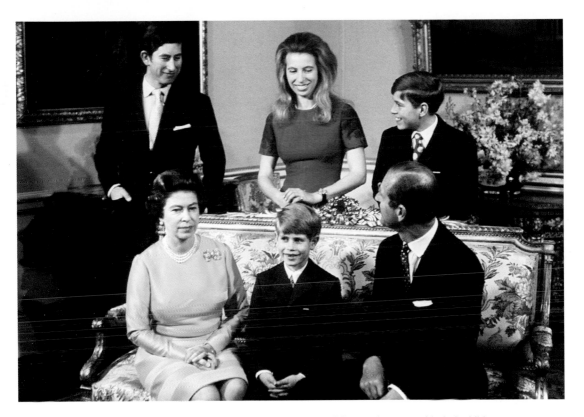

Queen Elizabeth II and Prince Philip on their silver wedding anniversary with their children:
Prince Charles, Princess Anne, Prince Andrew and Prince Edward.
November 1972

"Like all the best families, we have our share of eccentricities, of impetuous and wayward youngsters and of family disagreements."

Queen Elizabeth II.

"You're not wearing mink knickers are you?"

Duke of Edinburgh: To a fashion writer in 1993.

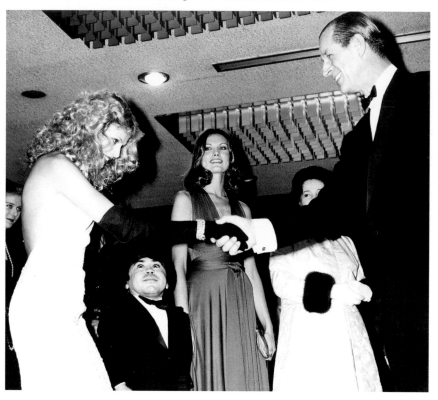

Prince Philip, Duke of Edinburgh at the Royal Premiere of the James Bond film *The Man with the Golden Gun*, at the Odeon Leicester Square, London. December, 1974

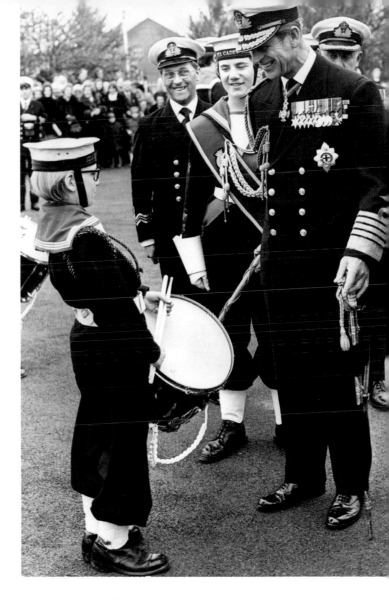

"Are we going to need ear plugs?"

Duke of Edinburgh: After being told that Madonna was to sing the theme to the James Bond film *Die Another Day* in 2002.

Prince Philip, Duke of Edinburgh inspects a Royal Guard of Sea Cadets at Knightsbridge in London. 1975

"It is an old cliché to say that the future is in the hands of the young. This is no longer true. The quality of life to be enjoyed or the existence to be survived by our children and future generations is in our hands now."

Duke of Edinburgh: Speech to the World Wildlife Fund Congress, London, 1970.

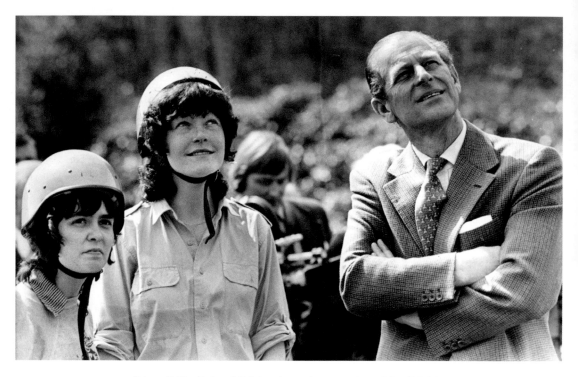

Prince Philip, Duke of Edinburgh meets youngsters at the Eskdale Outward Bound School in the Lake District.
1975

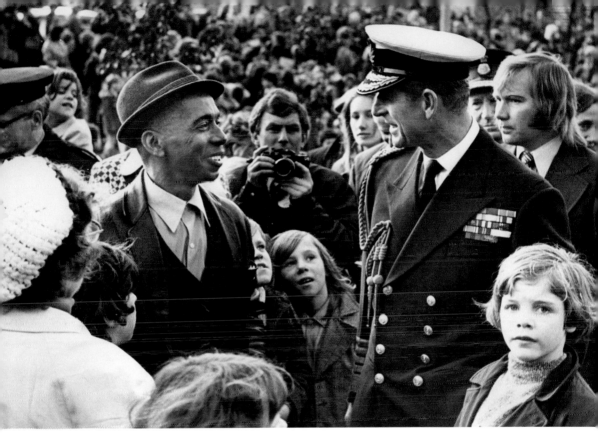

Prince Philip, Duke of Edinburgh chats to local people during a visit to the Byker Wall housing development in Byker, Newcastle upon Tyne.
1975

"What do you gargle with, pebbles?"

Duke of Edinburgh: Said to Tom Jones after the Royal Variety Performance. Later he added, "It is very difficult at all to see how it is possible to become immensely valuable by singing what I think are the most hideous songs", 1969.

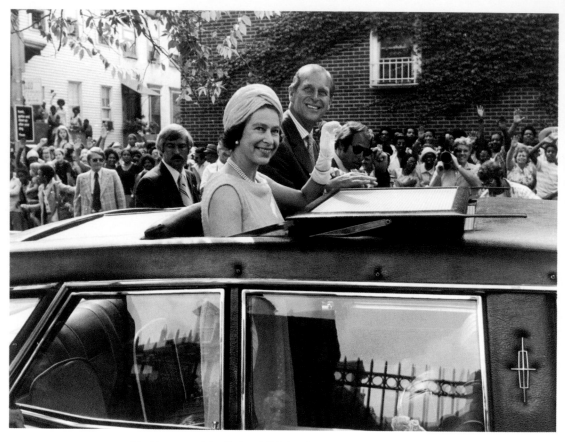

The Queen and the Duke of Edinburgh tour Harlem in New York.
12th July, 1976

"We don't come here for our health. We can think of other ways of enjoying ourselves."

Duke of Edinburgh: On a tour of Canada, 1976.

"Conservation must come before re-creation."

Prince Charles.

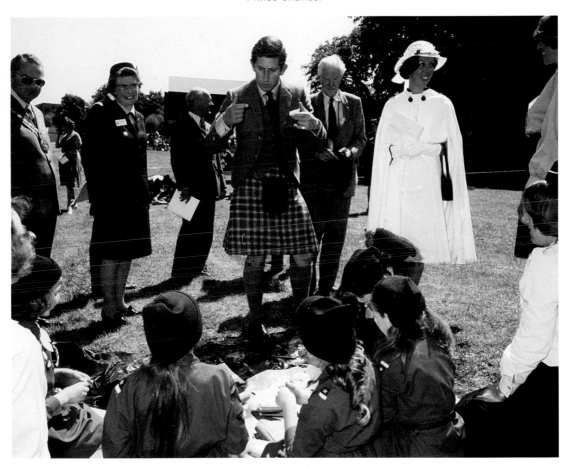

Clad in a kilt, Prince Charles gives a group of Brownies the benefit of his advice.
1977

"It's slightly complicated for people to grasp the idea of a head of state in human form."

Prince Andrew.

Prince Andrew as a boy with Queen Elizabeth II
at Badminton Horse Trials, Gloucestershire.
January, 1977

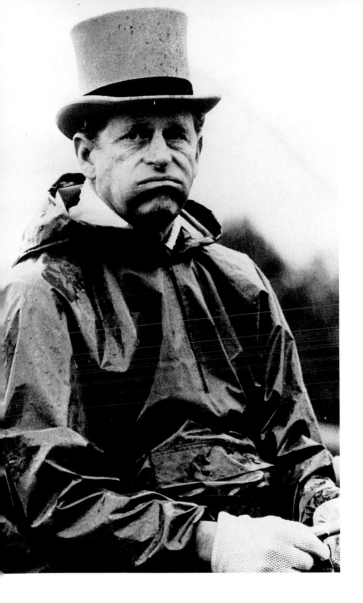

"**Cats kill far more birds than men. Why don't you have a slogan: 'Kill a cat and save a bird'?**"

Duke of Edinburgh:
Speaking at a project to
protect turtle doves in
Anguilla in 1965.

Prince Philip shows
what he thinks of
the weather during a
carriage driving event.
17th May, 1978

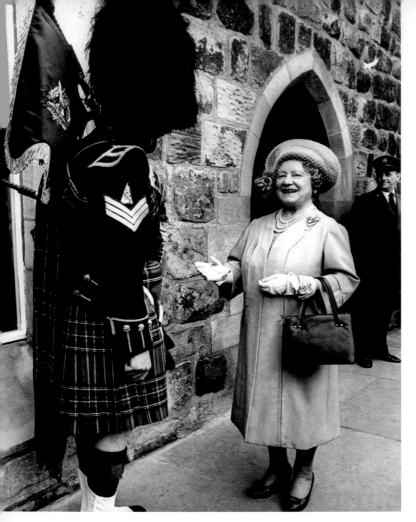

"Golly, I could do with £100,000, couldn't you? I had such an awful afternoon with my bank manager scolding me about my overdraft."

Queen Elizabeth
the Queen Mother.

Queen Elizabeth the Queen Mother chats with a piper at Blackfriars
Priory, Newcastle during a visit to the North East. She was known
for her love of the pipes.
16th April, 1980.

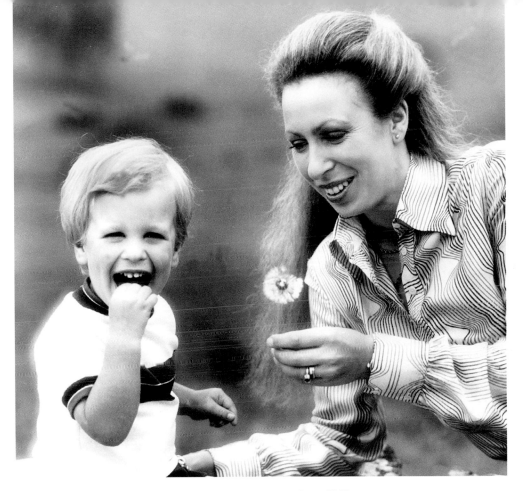

Princess Anne with her son, Peter Phillips.
August, 1980

"I know my own heart to be entirely English."

Princess Anne.

"Whatever 'in love' means."

Prince Charles: When asked if he was in love, after the announcement of his
engagement to Lady Diana Spencer, February, 1981.

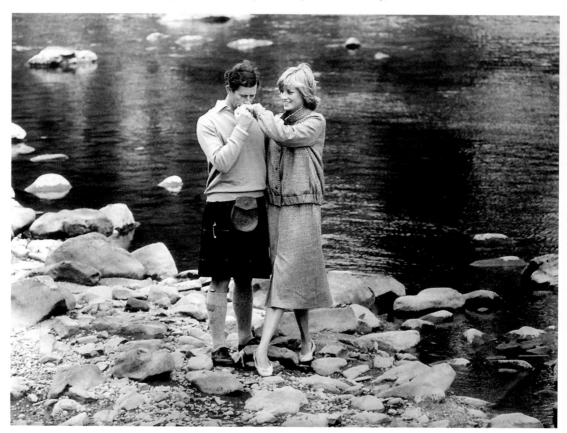

Prince Charles kisses the hand of Princess Diana while on honeymoon at Balmoral in Scotland.
1981

"People think there's a rigid class system here, but dukes have been known to marry chorus girls. Some have even married Americans."

Duke of Edinburgh, 2000.

Prince Philip, Duke of Edinburgh displays his carriage driving skills to Nancy Reagan, wife of US President Ronald Reagan, in Windsor Great Park during a Presidential visit to Britain. 8th June, 1982

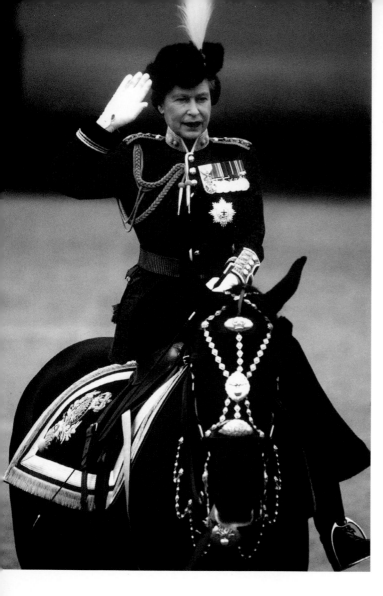

"**I have to be seen to be believed.**"

Queen Elizabeth II, 1986

Riding side-saddle, Queen Elizabeth II takes the salute during the Trooping the Colour ceremony in London. 16th June, 1984

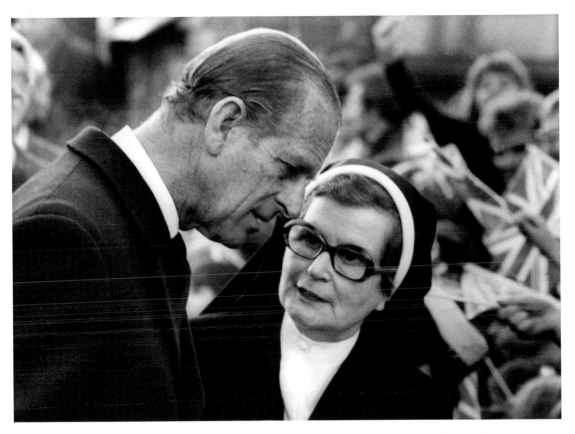

Prince Philip talks with Sister Philomena during a visit to St Cuthbert's Boys Club, Wigton, Cumbria.
1985

"You are a woman, aren't you?"

Duke of Edinburgh: After accepting a gift from a Kenyan woman,
as quoted in 'Long line of princely gaffes', BBC News, 1st March,
2002.

"If you stay here much longer, you'll all be slitty-eyed."

Duke of Edinburgh: To a group of British students in China in 1986, as quoted in 'Long line of princely gaffes', BBC News, 1st March, 2002.

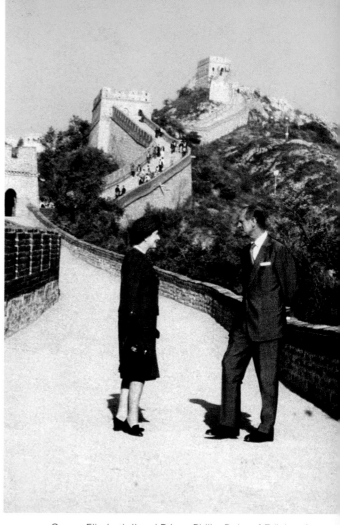

Queen Elizabeth II and Prince Philip, Duke of Edinburgh chat on the Great Wall of China during their state visit. October, 1986

"If it has four legs and is not a chair, has wings and is not an aeroplane, or swims and is not a submarine, the Cantonese will eat it."

Duke of Edinburgh: 1986 statement, as quoted in 'Long line of princely gaffes', BBC News, 1st March, 2002.

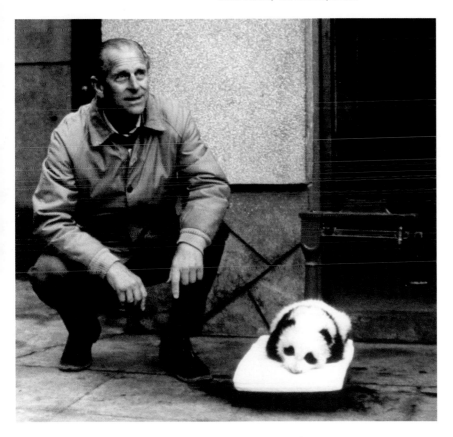

Prince Philip, Duke of Edinburgh with panda cub Li Li during the state visit to China. October, 1986

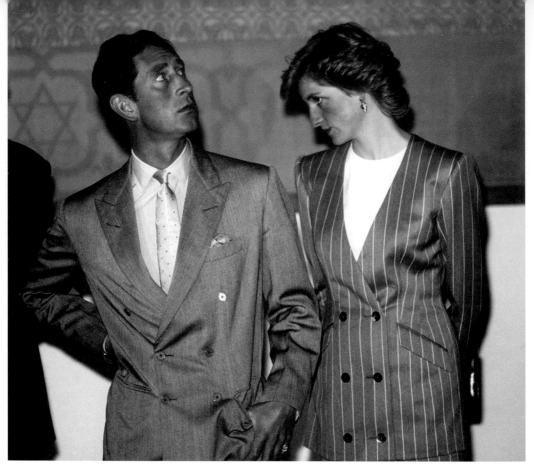

Prince Charles and Princess Diana visit a synagogue in the city of Toledo, Spain.
April, 1987

"Do you seriously expect me to be the first Prince of Wales in history not to have a mistress?"

Prince Charles: Quoted in *The Daily Mail*, 1994.

"Wouldn't it be terrible if you'd spent all your life doing everything you were supposed to do – didn't drink, didn't smoke, didn't eat things, took lots of exercise, all the things you didn't want to do – and suddenly one day you were run over by a big red bus, and as the wheels were crunching into you, you'd say, 'Oh my God, I could have got so drunk last night!' That's the way you should live your life, as if tomorrow you'll be run over by a big red bus."

Queen Elizabeth the Queen Mother.

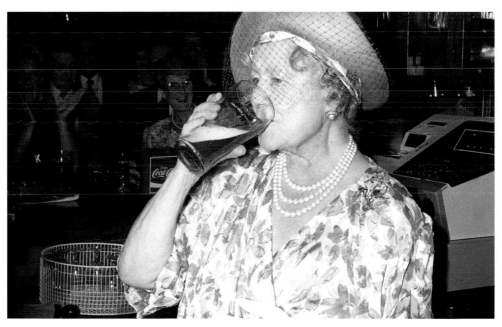

Queen Elizabeth the Queen Mother samples a pint of beer.
July, 1987

"Being a princess isn't all it's cracked up to be."

Princess Diana.

After Princess Diana sat on the bonnet of his Aston Martin during an equestrian event at Smiths Lawn, Windsor, Prince Charles discovered that she had dented it, causing an argument between the couple.
June, 1987

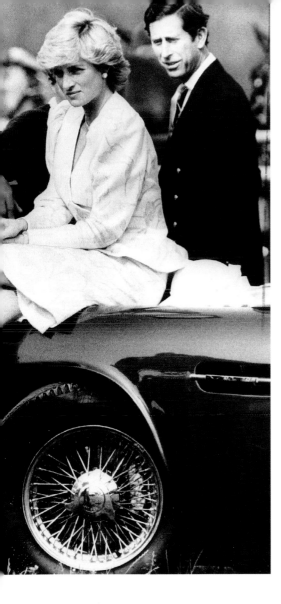
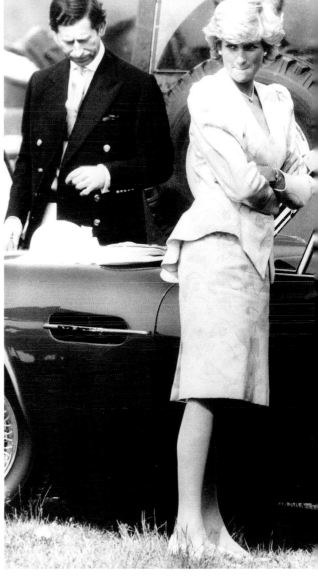

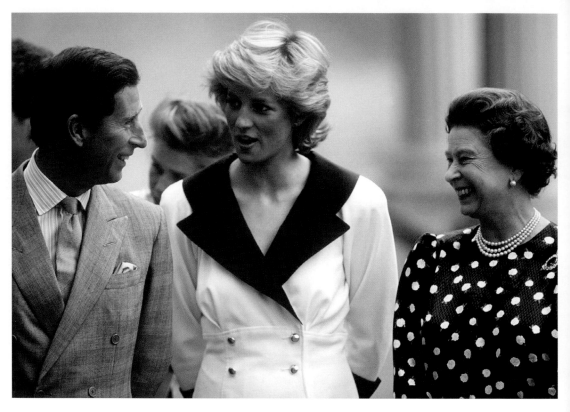

Prince Charles, Princess Diana and Queen Elizabeth II outside Clarence House in London
for the Queen Mother's 87th birthday.
5th August, 1987

"Family is the most important thing in the world."

Princess Diana.

"I don't think a prostitute is more moral than a wife, but they are doing the same thing."

Duke of Edinburgh, 1988.

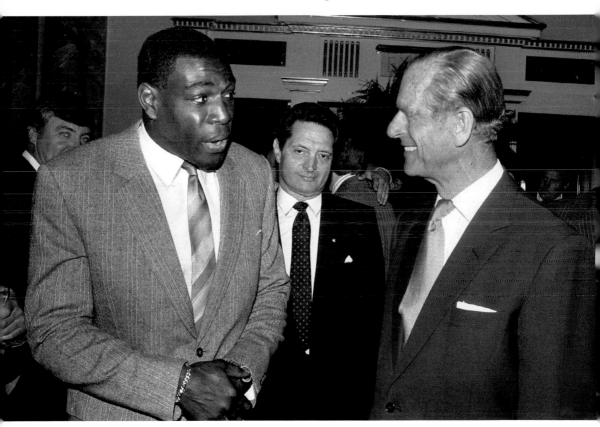

The Duke of Edinburgh chats with boxer Frank Bruno at a Variety Club lunch at the Dorchester, London.
25th May, 1988

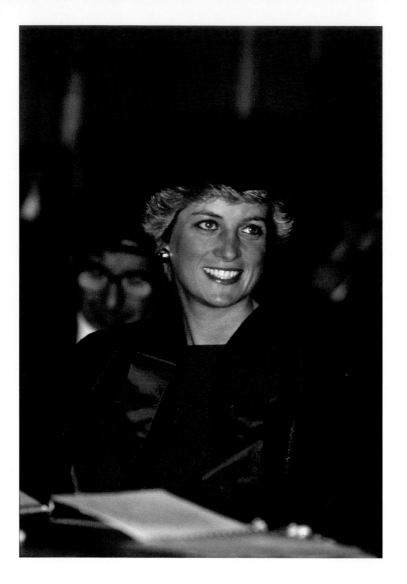

"I'm as thick as a plank."

Princess Diana.

Princess Diana receives an Honorary Fellowship of Dental Surgery during a ceremony at the Royal College of Surgeons, Lincoln's Inn Fields, London. June, 1988

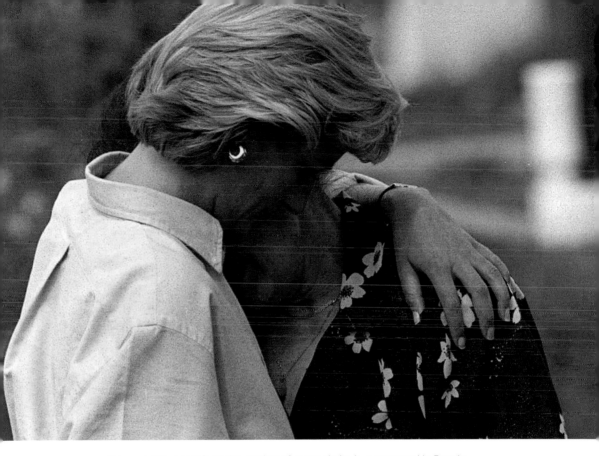

Princess Diana comforts the mother of a war victim in a graveyard in Bosnia.
August, 1988

Carry out a random act of kindness, with no expectation of reward, safe in the knowledge that one day someone might do the same for you.

Princess Diana.

"I want to walk into a room, be it a hospital for the dying or a hospital for the sick children, and feel that I am needed. I want to do, not just to be."

Princess Diana.

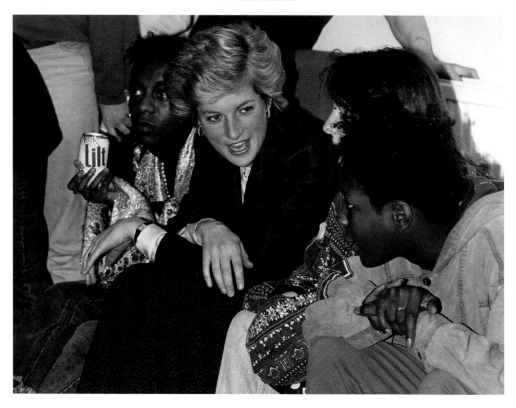

Princess Diana chats with young people at a day centre for the young homeless.
February, 1990

Princess Diana laughs with members of the public during a visit
to St Peter's Basin, Newcastle upon Tyne.

"**I knew what my job was; it was to go out and
meet the people and love them.**"

Princess Diana.

"Duty first, self second."

Queen Elizabeth II.

Queen Elizabeth II at the Trooping the Colour ceremony on Horse Guards Parade, London.
May, 1991

<blockquote>
"I wear my heart on my sleeve."
</blockquote>

Princess Diana.

Princess Diana visits The Royal Hampshire Regiment, who were celebrating the 1759 Battle of Minden, in commemoration of which the soldiers wore red roses in their hats. As Colonel in Chief of the regiment, Diana honoured the occasion by wearing a rose on her white dress. August, 1991

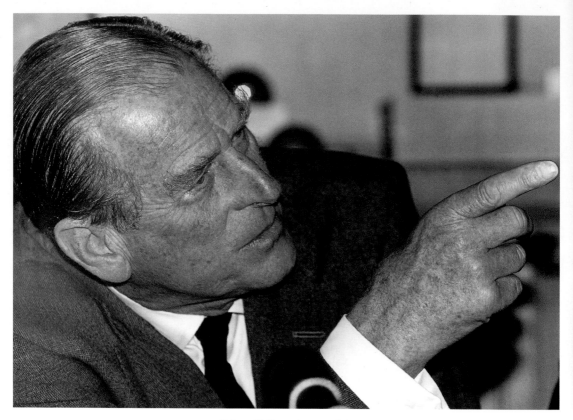

Prince Philip makes a point.
December, 1991.

"Vastly exaggerated."

Duke of Edinburgh: Commenting on the Jallianwala Bagh massacre in Amritsar, India in 1919, when British troops fired on thousands of demonstrators. Official British figures quote 379 killed, although other sources suggest as many as 1,526.

Princess Diana visits the Whitemoor Day Centre, Belper, Derbyshire.
April, 1992

"The biggest disease this day and age is that of people feeling unloved."

Princess Diana.

"**They say it is better to be poor and happy than rich and miserable, but how about a compromise like moderately rich and just moody?**"

Princess Diana.

Princess Diana arrives at her family's former ancestral home, Spencer House, in London. May, 1992

"There is something about going to sea. A little bit of discipline, self-discipline and humility are required."

Prince Andrew.

Prince Andrew inspects
Sea Cadets in Trafalgar
Square, London during
the annual Trafalgar
Day Service held to
commemorate Nelson's
famous victory.
October, 1992

"There were three of us in this marriage, so it was a bit crowded."

Princess Diana: Commenting on Prince Charles' affair
with Camilla Parker-Bowles in a BBC interview, 1995.

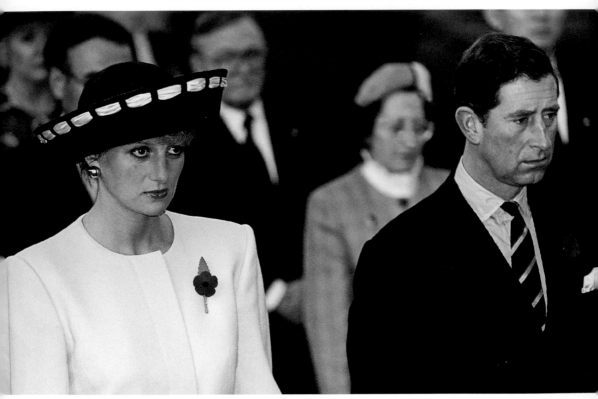

During an official visit to Korea, it was clear that all was not well
between Prince Charles and Princess Diana.
1992

The Queen is escorted by the chief fire officer around the grounds of Windsor Castle
as firefighters battle the blaze in the castle's Brunswick Tower.
20th November, 1992

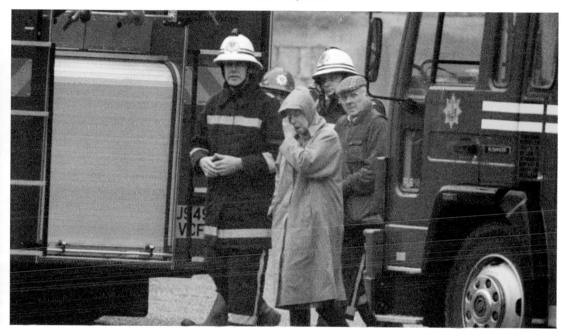

"1992 is not a year on which I shall look back with undiluted pleasure. In the words of one of my more sympathetic correspondents, it has turned out to be an *annus horribilis*."

Queen Elizabeth II: After enduring a fire at Windsor Castle and several personal scandals within the Royal family. *Annus horribilis* is Latin for 'horrible year'; the correspondent to whom the Queen was referring was Sir Edward Ford. Her comments were made in a speech at the Guildhall, London to mark the 40th anniversary of her accession, 24th November, 1992.

"You can't have been here that long — you haven't got a pot belly."

Duke of Edinburgh: Said to a Briton in Budapest, Hungary in 1993, as quoted in 'Long line of princely gaffes', BBC News, 1st March, 2002.

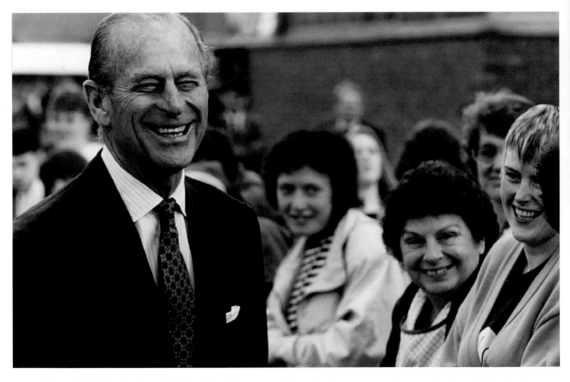

Prince Philip the Duke of Edinburgh smiles as he talks to local women during a walk-about in Scotland.
June, 1993

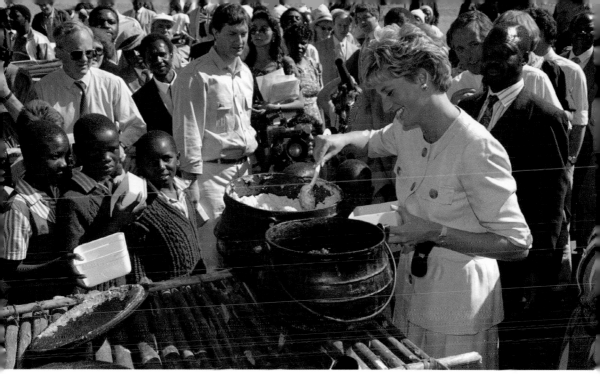

Princess Diana helps to feed schoolchildren during a visit to Zimbabwe.
19th July, 1993

"Anywhere I see suffering, that is where I want to be, doing what I can."

Princess Diana.

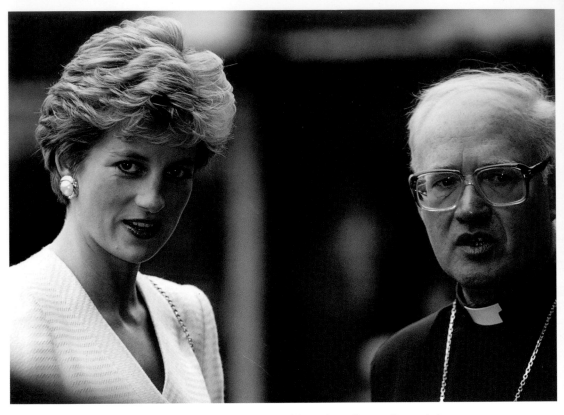

Princess Diana and the Archbishop of Canterbury, George Carey, during
an awards presentation for mission volunteers at Lambeth Palace, London.
October, 1993

"I don't go by the rule book... I lead from the heart, not the head."

Princess Diana.

"I live for my sons. I would be lost without them."

Princess Diana.

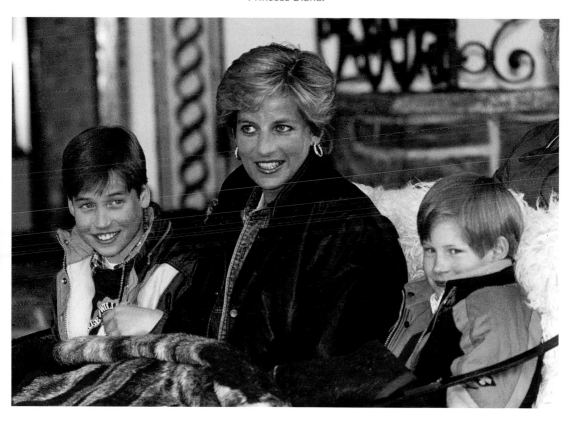

Princess Diana with Princes William and Harry on holiday in Austria.
November, 1993

Prince Philip, Duke of Edinburgh during a visit to
Tyneside engineering company A. Reyrolle.
1994

"A pissometer?"

Duke of Edinburgh: On being shown a piezo-meter
water gauge in Australia.

"All the time I feel I must justify my existence."

Prince Charles.

Prince Charles in deep meaningful conversation with Boo Boo the clown during a Prince's Youth Business Trust event at St James's Palace, London.
April, 1995

"Golf seems to be an arduous way to go for a walk. I prefer to take the dogs out."

Princess Anne.

Princess Anne indicates
her displeasure.
27th July, 1995

Prince Charles, Princess Diana and Prince Harry, with Princess Anne behind,
walk from Buckingham Palace to attend VJ Day celebrations in London.
19th August, 1995

"What must it be like for a little boy to read that Daddy never loved Mummy?"

Princess Diana.

"The British constitution has always been puzzling and always will be."

Queen Elizabeth II.

Queen Elizabeth II arrives at Westminster for the State Opening of Parliament with Prince Philip, Duke of Edinburgh.
15th November, 1995

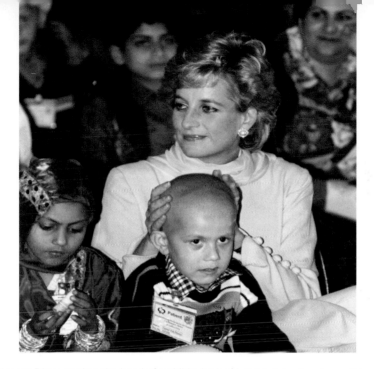

Princess Diana strokes the head of a child who had lost his hair after chemotherapy treatment at the Shaukat Khanum Memorial Cancer Hospital in Lahore, Pakistan. 22nd February, 1996.

"Don't call me an icon. I'm just a mother trying to help."

Princess Diana.

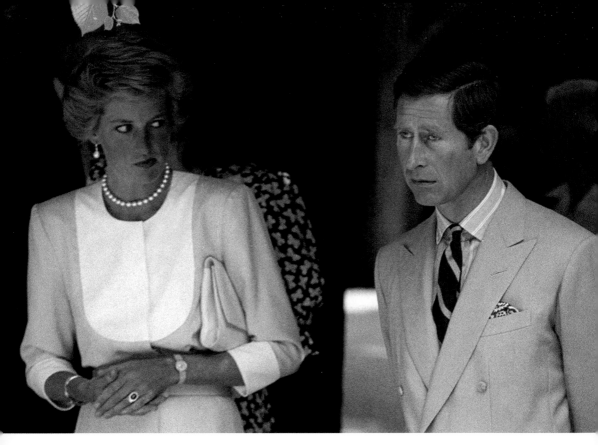

Princess Diana and Prince Charles during a state visit to Hungary.
March, 1996

"I think like any marriage, especially when you've had divorced parents like myself, you want to try even harder to make it work."

Princess Diana.

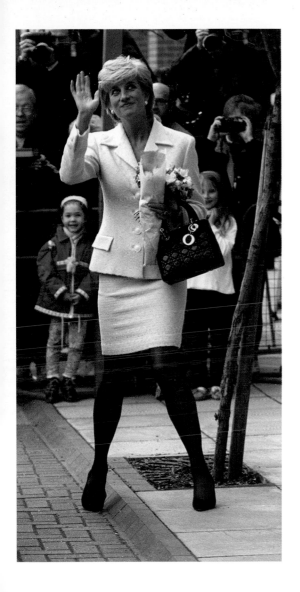

"I like to be a free spirit. Some don't like that, but that's the way I am."

Princess Diana.

Princess Diana visits a neurology hospital in London, her first public engagement since agreeing to a divorce from Prince Charles.
6th March, 1996

Prince Philip, Duke of Edinburgh makes a speech in Glasgow.
9th October, 1996

"If a cricketer, for instance, suddenly decided to go
into a school and batter a lot of people to death with
a cricket bat, which he could do very easily,
I mean, are you going to ban cricket bats?"

Duke of Edinburgh: Commenting on the Dunblane shooting
in Scotland, where 16 schoolchildren and a teacher were
killed by gunman Thomas Hamilton on 13th March, 1996.

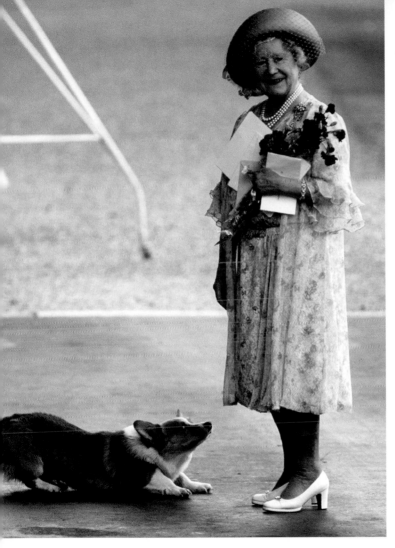

"Your work is the rent you pay for the room you occupy on earth."

Queen Elizabeth the Queen Mother.

Queen Elizabeth the Queen Mother and canine friend.
17th October, 1996

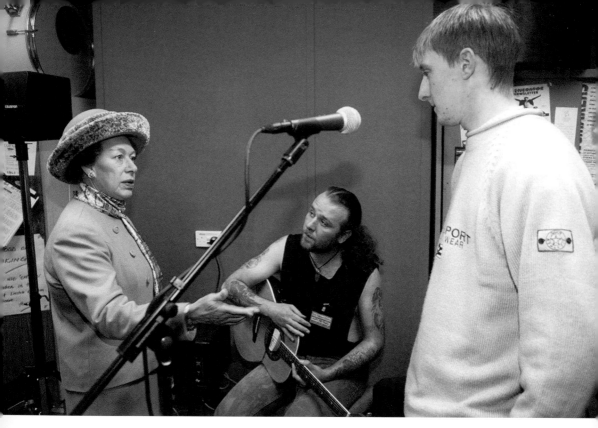

Princess Margaret chats with musicians after opening the
Eric Tolhurst Centre in Blyth, Northumberland.
11th November, 1996

"I have as much privacy as a goldfish in a bowl."

Princess Margaret.

"I think the biggest disease the world suffers from in this day and age is the disease of people feeling unloved. I know that I can give love for a minute, for half an hour, for a day, for a month, but I can give. I am very happy to do that, I want to do that."

Princess Diana.

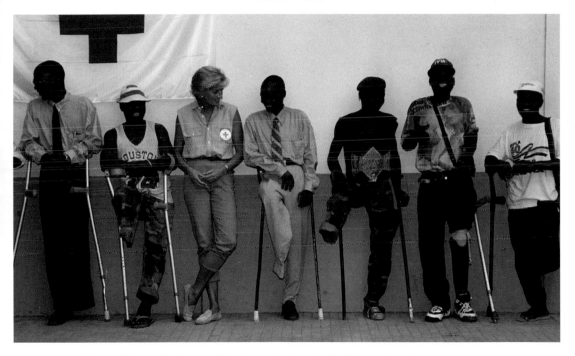

Princess Diana with victims of landmines in Angola. The Princess lent her support to the campaign to ban the use of such weapons, but was criticised for being so outspoken.
January, 1997

"Only do what your heart tells you."

Princess Diana.

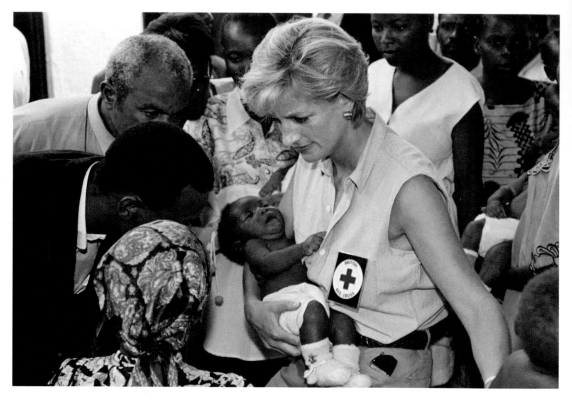

Princess Diana visits a Red Cross centre in Angola.
14th January, 1997

"People think that at the end of the day a man is the only answer. Actually, a fulfilling job is better for me."

Princess Diana.

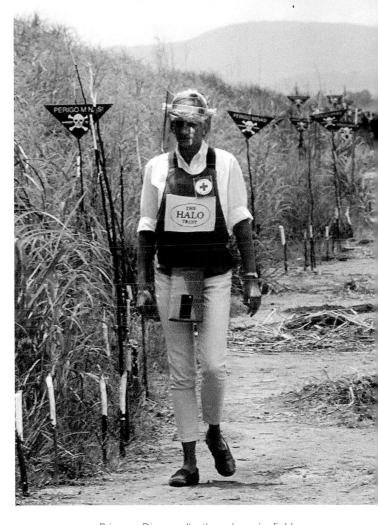

Princess Diana walks through a minefield during her visit to Angola.
15th January, 1997

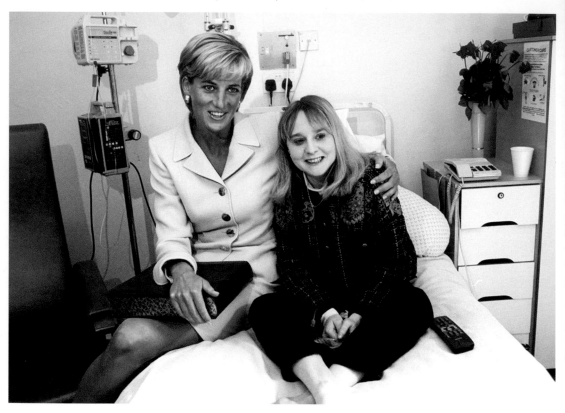

Princess Diana with cystic fibrosis sufferer Nicky Welsh at Brompton Hospital in London.
The Princess was there to promote awareness of the disease.
15th April, 1997

"Hugs can do great amounts of good, especially for children."

Princess Diana.

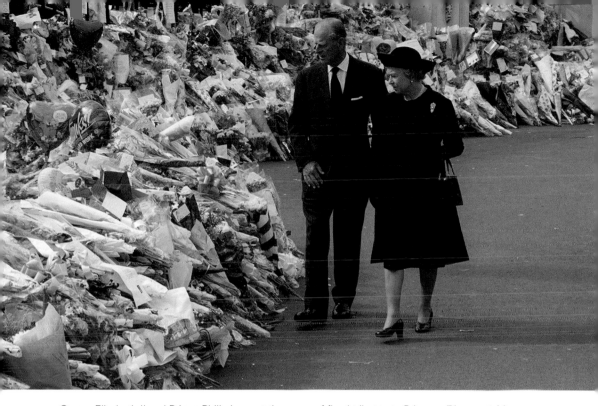

Queen Elizabeth II and Prince Philip inspect the mass of floral tributes to Princess Diana outside Buckingham Palace in London. The Princess had died in a car crash in Paris six days earlier.
5th September, 1997

"No one who knew Diana will ever forget her.
Millions of others who never met her, but felt
they knew her, will remember her."

Queen Elizabeth II: Speech on the death of Diana, Princess of
Wales. 9th September, 1997.

"I'd like to be a queen in people's hearts, but I don't see myself being queen of this country."

Princess Diana.

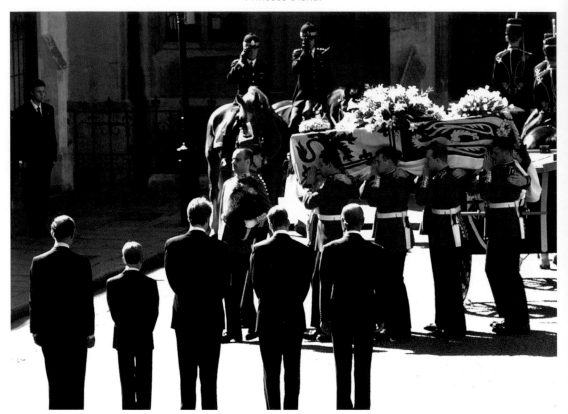

The funeral of Princess Diana. L–R: Prince Charles, Prince Harry, Earl Spencer, Prince William and the Duke of Edinburgh watch the coffin bearing the body of the Princess as it is taken into Westminster Abbey for the funeral service. Millions of mourners lined the streets of central London to watch the funeral procession.
6th September, 1997

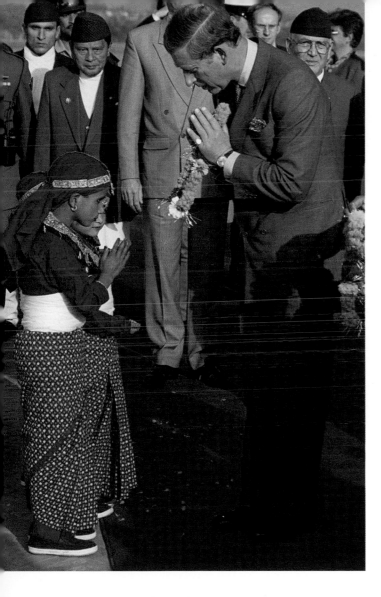

"**I sometimes wonder if two-thirds of the globe is covered in red carpet.**"

Prince Charles.

Prince Charles is greeted by the Young Virgins (Kumari) during his visit to Nepal. The girls are worshipped as goddesses. February, 1998

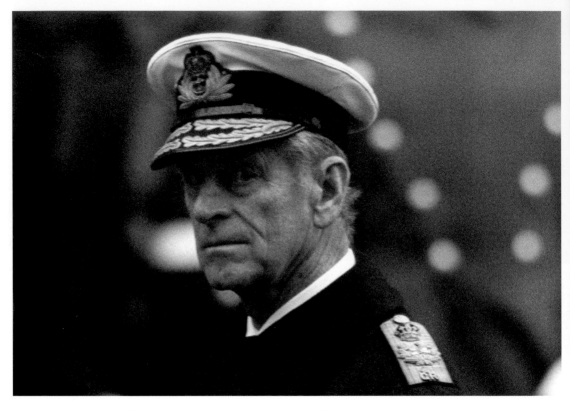

Prince Philip at the Remembrance Day Service at The Cenotaph in Whitehall, London.
November, 1998

"Damn fool question!"

Duke of Edinburgh: To BBC journalist Caroline Wyatt, who had
asked whether the Queen was enjoying a visit to Paris, 2006.

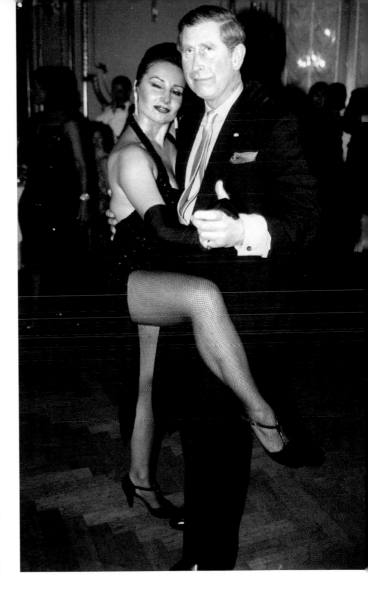

"Father told me that if I ever met a lady in a dress like yours, I must look her straight in the eyes."

Prince Charles.

A bemused Prince Charles dances the tango with Adriane Vasile at a Presidential dinner in Buenos Aires, Argentina, where he was on a two-day state visit. 9th March, 1999

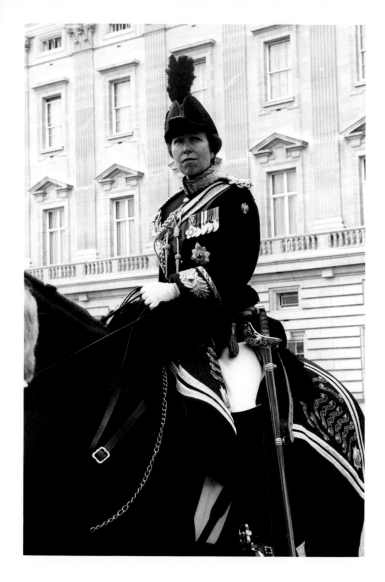

"When I appear in public, people expect me to neigh, grind my teeth, paw the ground and swish my tail – none of which is easy."

Princess Anne.

Princess Anne taking part in the Trooping the Colour Ceremony at Horse Guards Parade, London. 12th June, 1999

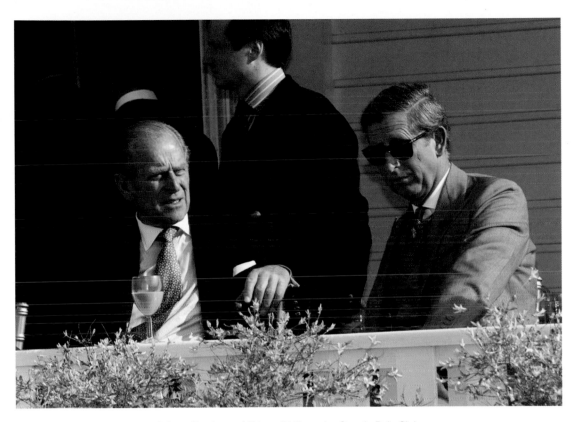

Prince Charles and Prince Philip at the Guards Polo Club,
Windsor Great Park for the Eton Tea Party.
16th June, 1999

"You didn't design your beard too well, did you? You really must try better with your beard."

Duke of Edinburgh: To a young fashion designer at
Buckingham Palace, 2009.

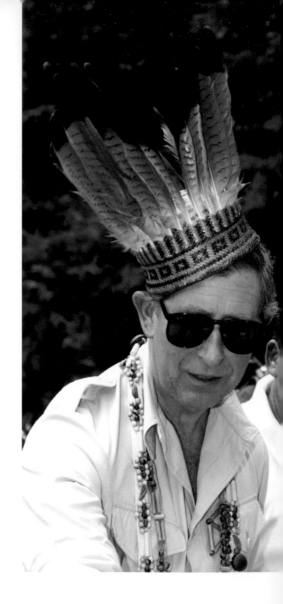

"What I want to know is: what is actually wrong with an elite?"

Prince Charles: Newspaper quote, 1985.

Prince Charles wears a headdress made of feathers while visiting the Iwokrama Forest conservation area in central Guyana. 27th February, 2000

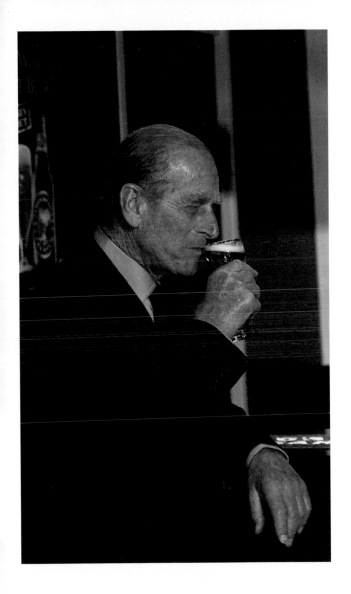

"**How do you keep the natives off the booze long enough to get them through the test?**"

Duke of Edinburgh: To a driving instructor in Scotland, as quoted in 'Long line of princely gaffes', BBC News, 1st March, 2002.

Prince Philip enjoys a glass of beer at Boag's Brewery in Launceston, Tasmania during a visit to Australia.
March, 2000

Prince Philip during a visit to Australia.
April, 2000

"Ghastly!"

Duke of Edinburgh: When asked his opinion of
Beijing, during a state visit to China in 1986.

"I have always had a dread of becoming a passenger in life."

Princess Margaret.

Princess Margaret during a visit to the Chelsea Flower Show. She had suffered severe scalding to her feet in a bathroom accident the year before, which restricted her mobility.
May, 2000

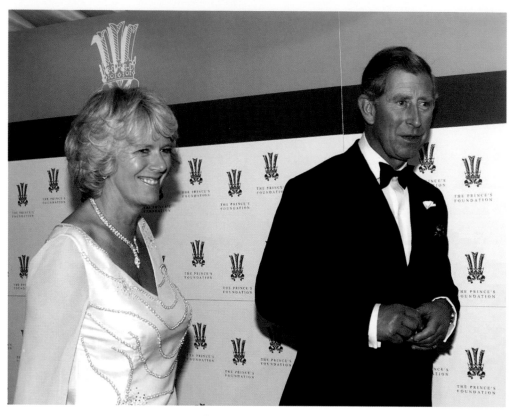

The Prince of Wales and Camilla Parker Bowles attend a dinner to mark the official opening of the newly restored building in the City of London that is the headquarters of the Prince's Foundation.
June, 2000

"I'm just coming down to earth."

Camilla, Duchess of Cornwall: After the announcement of her engagement to
Prince Charles in February, 2005.

"Never trust them, never trust them. They can't be trusted."

Queen Elizabeth the Queen Mother: Referring to the Germans.

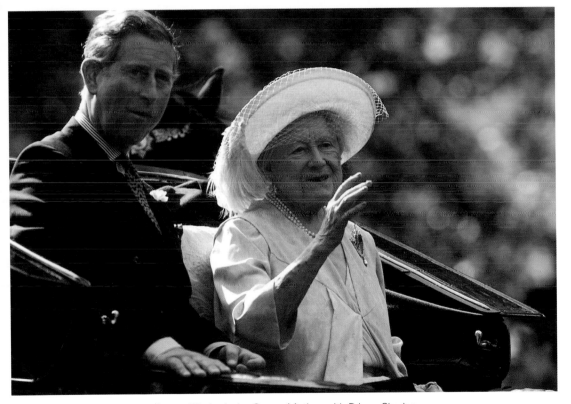

Queen Elizabeth the Queen Mother with Prince Charles
during her 100th birthday pageant in London.
19th July, 2000

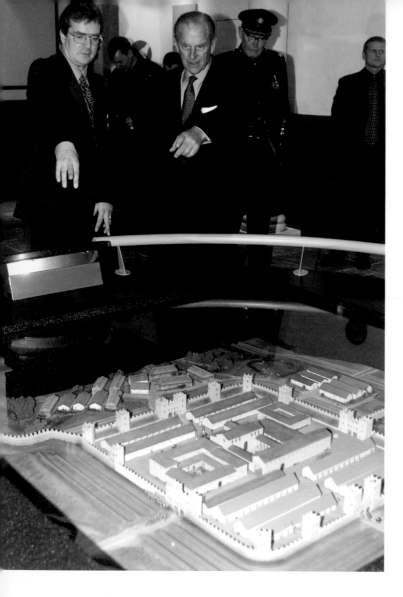

"It looks like the kind of thing my daughter would bring back from her school art lessons."

Duke of Edinburgh: When viewing 'primitive' Ethiopian art, 1965.

Prince Philip inspects a model of Segedunum Roman Fort during a visit to the site at Wallsend, Newcastle upon Tyne.
7th December, 2000

"But nothing that can be said can begin to take away the anguish and the pain of these moments. Grief is the price we pay for love."

Queen Elizabeth II: Part of a message from the Queen, read by the British ambassador to Washington, Sir Christopher Meyer, during a memorial service for the victims of the destruction of the World Trade Center at St Thomas Church on Fifth Avenue, New York, 22nd September, 2001.

Queen Elizabeth II at St Paul's Cathedral, London following a memorial service
for the victims of the New York World Trade Center attack.
14th September, 2001

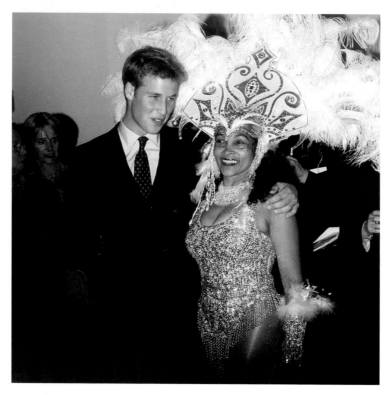

Prince William with a glamorous dancer during a visit to Glasgow
with his father, Prince Charles.
21st September, 2001

"Only the mad girls chase me, I think."

Prince William.

"Have you been playing a long time?"

Queen Elizabeth II: Speaking to rock legend Eric Clapton about his guitar playing at a Buckingham Palace reception for the British music industry in March, 2005.

The Queen and Prince Philip listen to a children's choir at The Sage centre for music and art in Gateshead, Tyne and Wear.
2002

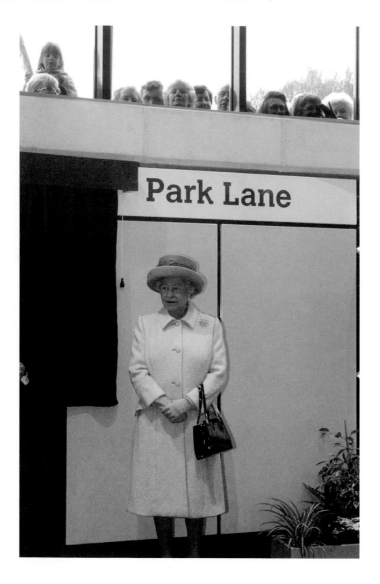

"I have behind me not only the splendid traditions and the annals of more than a thousand years, but the living strength and majesty of the Commonwealth and Empire; of societies old and new; of lands and races different in history and origins but all, by God's will, united in spirit and in aim."

Queen Elizabeth II:
Coronation speech, 1953.

Queen Elizabeth II opens
the Park Lane Metro Station
in Sunderland.
2002

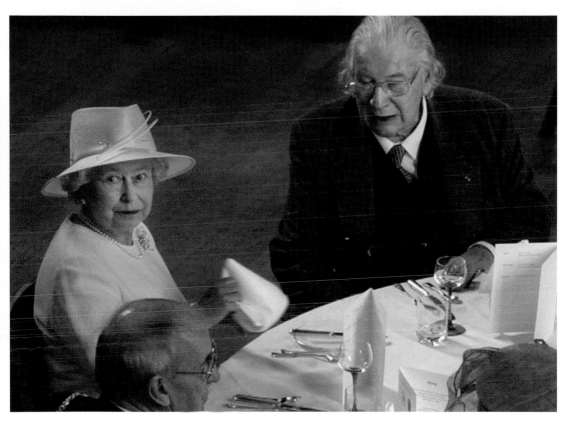

During a visit to Durham, Queen Elizabeth II takes lunch with Sir Peter Ustinov (R).
2002

"I myself prefer my New Zealand eggs for breakfast."

Queen Elizabeth II: After she was pelted with eggs by women protestors
during a visit to a school in New Zealand, 24th February, 1986.

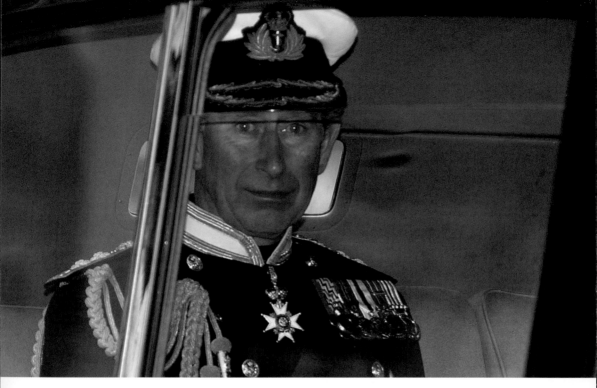

An emotional Prince Charles on his way to the funeral of his
grandmother, Queen Elizabeth the Queen Mother.
9th April, 2002

"I think, as probably many of you will know from the
experience of family loss, perhaps in your own lives,
it is inevitably very difficult to cope with grief at any
time, but perhaps you might realise it is even harder
when the whole world is watching."

Prince Charles.

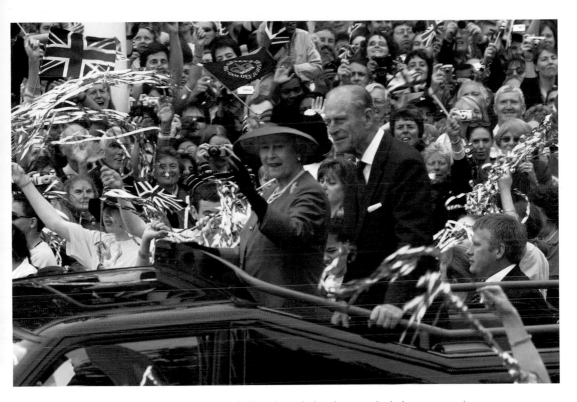

Queen Elizabeth II and Prince Philip acknowledge the crowds during a procession
along The Mall in London that formed part of the celebrations for her Golden Jubilee.
4th June, 2002

"We are a moderate, pragmatic people, more comfortable with practice than theory."

Queen Elizabeth II: Speech in reply to addresses from both Houses of Parliament
in Westminster Hall in the year of her Golden Jubilee, 30th April, 2002.

"French cooking's all very well, but they can't do a decent English breakfast."

Duke of Edinburgh: Comment aboard the floating restaurant 'Il Punto' (owned by Frenchman Regis Crépy) on the River Orwell in Ipswich, after he had enjoyed an excellent full English breakfast, 2002.

The Duke of Edinburgh, Princess Anne, Prince Edward, Prince Harry, Prince Charles and other members of the Royal family attend a Christmas Day service at St Mary's church on the Sandringham estate in Norfolk. 25th December, 2002

"There is no way I am going to put myself through Sandhurst and then sit on my arse back home while my boys are out fighting for their country."

Prince Harry: On his desire to be deployed in the Iraq War, 2005.

Prince Harry acts as the parade commander of the 48-strong guard of honour at the Combined Cadet Force's Tattoo at Eton College. May, 2003

Prince Charles visits the Central Mosque in Glasgow during a tour of Scotland.
12th June, 2003

"You have to give this much to the Luftwaffe: when it knocked down our buildings, it did not replace them with anything more offensive than rubble. We did that."

Prince Charles.

"At the moment, it looks as though London seems to be turning into an absurdist picnic table: we already have a giant gherkin, now it looks as if we are going to have an enormous salt cellar."

Prince Charles: Comment on the design of Renzo Piano's 1,000ft-high 'Shard of Glass' London Bridge Tower, 2003.

Prince Charles makes a speech at the headquarters of Disability Action in Belfast, Northern Ireland. 2nd September, 2003

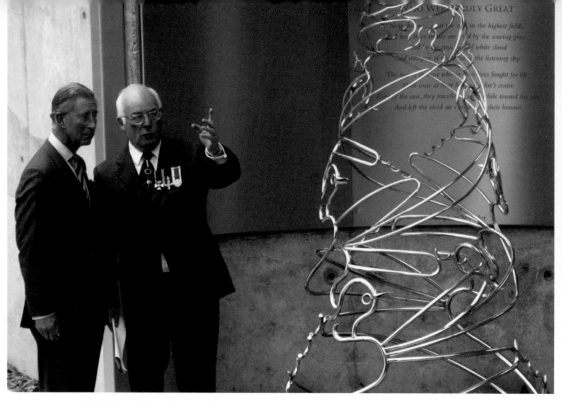

Jim McDonald, chairman of the Royal Ulster Constabulary George Cross Foundation, shows a singularly unimpressed Prince Charles a sculpture in the Garden of Remembrance at the headquarters of the Police Service of Northern Ireland in Belfast.
September, 2003

"Why can't we have those curves and arches that express feeling in design? What is wrong with them? Why has everything got to be vertical, straight, unbending, only at right angles – and functional?"

Prince Charles.

"I'm a dangerous person because I mind about things."

Prince Charles.

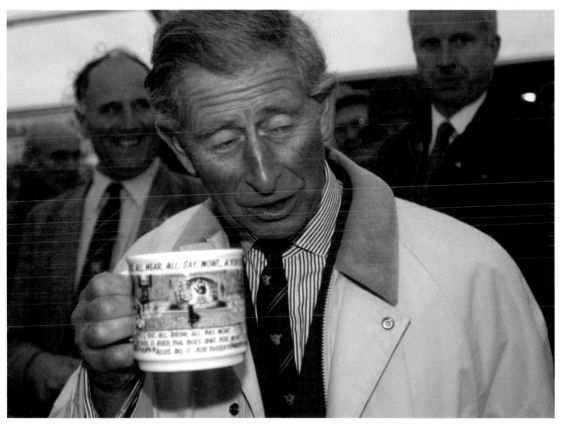

A man who clearly enjoys a tipple, Prince Charles samples damson wine
at the Nidderdale Show, Yorkshire.
22nd September, 2003

"I just come and talk to the plants – really very important to talk to them; they respond I find."

Prince Charles.

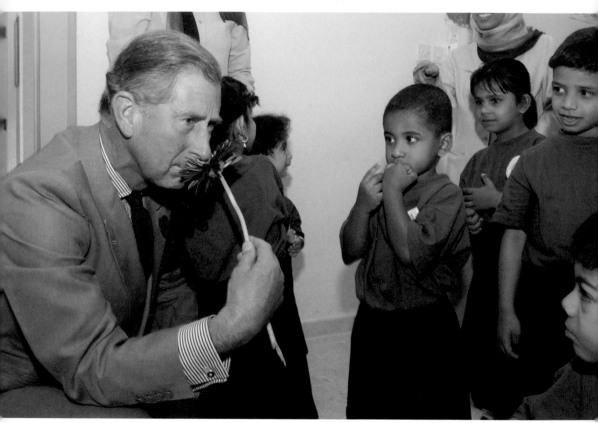

Prince Charles visits a school for children with special needs in Muscat, Oman.
8th November, 2003

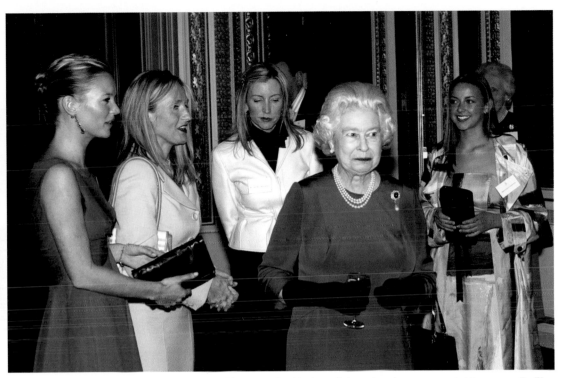

Queen Elizabeth II, at a lunch for women achievers at Buckingham Palace, London, seems glad to escape (L–R) Kate Moss, J.K. Rowling, Heather Mills and Charlotte Church.
11th March, 2004

"Oh, dear, I hope it wasn't anyone important."

Queen Elizabeth II: Said to Clare Short after Short's phone rang in her handbag during a Privy Council meeting; quoted in Donald Macintyre, 'The Queen is on a roll because she understands her role (unlike her son),' *The Independent*, 2nd May, 2002.

"A monstrous carbuncle on the face of a much-loved and elegant friend."

Prince of Wales: Comment on the proposed extension
to the National Gallery in London, May, 1984.

Prince Charles chats with singer Will Young (L), in the Royal box at the Party in the Park, Hyde Park, London. The
music festival had been organised as a fund-raiser for the Prince's Trust.
10th July, 2004

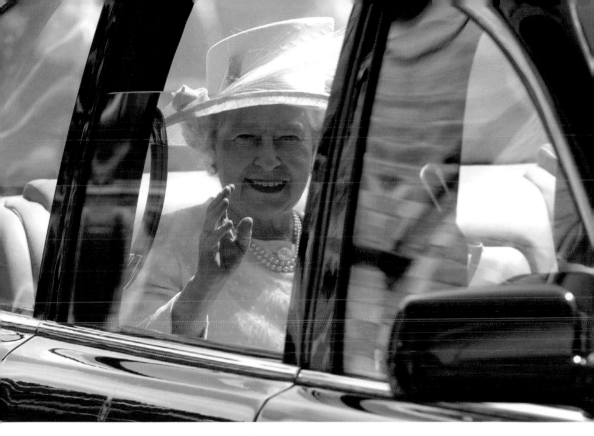

Queen Elizabeth II leaves the University of St Andrews following Prince William's graduation ceremony.
23rd June, 2005

"Are you a guitarist too?"

Queen Elizabeth II: To Led Zeppelin's Jimmy Page, who wrote the famous
song Stairway to Heaven, during a Buckingham Palace reception for the music
industry, March, 2005.

"**She's always been very close to me and William… She's not the wicked stepmother. She's a wonderful woman and she's made our father very, very happy, which is the most important thing.**"

Prince Harry: On his stepmother Camilla, Duchess of Cornwall.

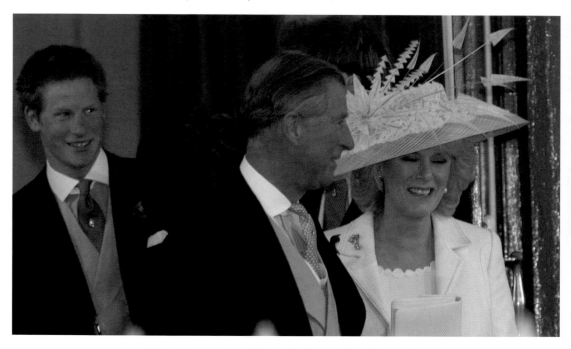

Prince Harry watches Prince Charles and Camilla leave the Windsor Guildhall after their civil marriage ceremony.
9th April, 2005

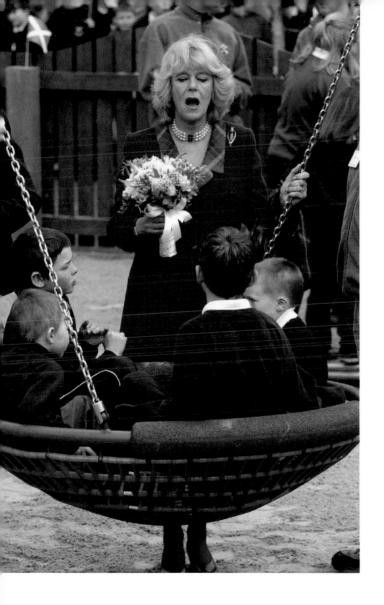

"English students don't spend much time on their studies. They're more interested in partying and having fun."

Camilla, Duchess of Cornwall: A comparison with 'hardworking' Pakistani students, which angered the National Union of Students, October, 2006.

On their honeymoon in Scotland, Prince Charles and his second wife, Camilla Parker Bowles, who had been given the title Duchess of Cornwall, took time out to open a new children's playground in Ballater. Here the newly appointed Duchess addresses a bowl of children. 14th April, 2005

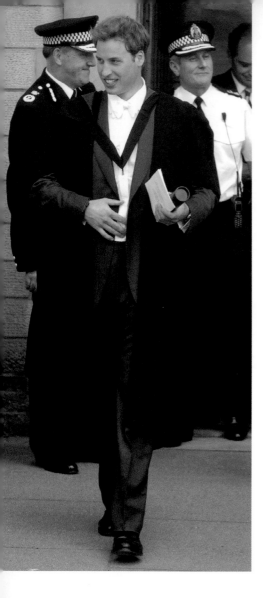

"I hope I'm not a tourist attraction – I'm sure that they come here really because St Andrews is just amazing, a beautiful place."

Prince William: Commenting on his time at the University of St Andrews, Fife, Scotland.

Prince William at his graduation from the University of St Andrews in Scotland.
23rd June, 2005

The Duchess Of Cornwall meets the calendar girls. The women had posed nude or semi-nude for a Women's Institute calendar to raise funds for leukaemia research. Their story was turned into a film starring Helen Mirren and Julie Waters.
1st June, 2005

"Oh, it's quite all right, we curse quite a lot around here."

Camilla, Duchess of Cornwall: To Sharon Osbourne, wife of rock star Ozzy, who caused a stir when she told Prince Charles' consort, "I think you're fucking great" during a Queen's Golden Jubilee concert at Buckingham Palace, June, 2002.

"Surely the time has come to escape from an almost adolescent obsession with being 'modern' – the product, perhaps, of a 20th-century 'teenage crisis'? – and, instead, to be more concerned about being 'human'!"

Prince Charles: Speech entitled 'Local Identity in a Fast-Track Age', November, 2004.

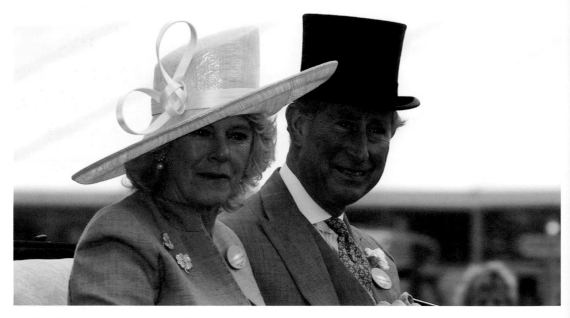

Prince Charles and his new wife, Camilla, Duchess of Cornwall, at Royal Ascot, which in 2005 was held at York due to Ascot racecourse undergoing a major redevelopment.
14th June, 2005

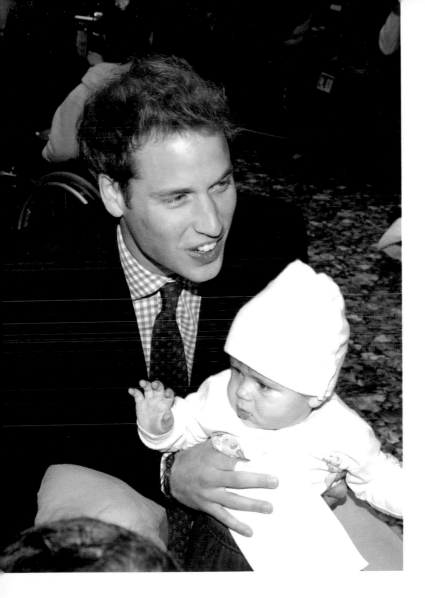

"My guiding principles in life are to be honest, genuine, thoughtful and caring."

Prince William.

Prince William shows that he has inherited his mother's affinity with children with one-year-old Kennard Nanau at the Auckland Children's Hospital, New Zealand. 5th July, 2005

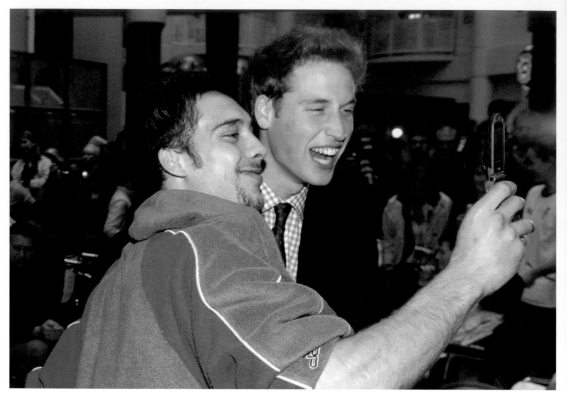

During Prince William's visit to the Auckland Children's Hospital, Dylan Harris took the opportunity to grab a photo with his camera phone.
5th July, 2005

"Everybody thinks I drink beer, but I actually like cider!"

Prince William.

"I do enjoy running down a ditch full of mud, firing bullets. It's the way I am. I love it."

Prince Harry: Quoted in the *Daily Mail*, 27th April, 2007.

Prince Harry on a military exercise in Ashdown Forest, East Sussex, as part of his Sandhurst military training. 2005

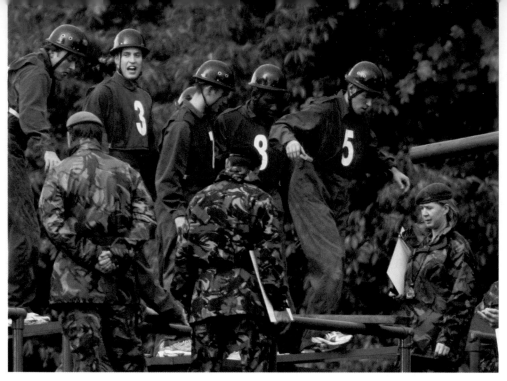

Prince William (second L, number 3) during an Army officer training course
at Westbury in Wiltshire.
20th October, 2005

"The last thing I want to do is be mollycoddled or be
wrapped up in cotton wool, because if I was to join the
Army, I would want to go where my men went, and I'd
want to do what they did. I would not want to be kept back
for being precious, or whatever – that's the last thing I
would want."

Prince William.

"Those who perpetrate these brutal acts against innocent people should know that they will not change our way of life."

Queen Elizabeth II: Commenting on the terrorist bombing attack on London's transport system on 7th July, 2005.

Queen Elizabeth II leads the nation in remembrance during the Remembrance Day Service at The Cenotaph in Whitehall, London.
13th November, 2005

Prince Harry (second R) can't help but grin as his grandmother, Queen Elizabeth II, inspects the Sovereign's Parade at the Royal Military Academy in Sandhurst. He was one of the cadets passing out as commissioned officers.
12th April, 2006

"I would never want to put someone else's life in danger when they have to sit next to the bullet magnet. But if I'm wanted, if I'm needed, then I will serve my country as I signed up to do."

Prince Harry: Quoted in *The Washington Post*, 29th February, 2008.

"The bastards murdered half my family."

Duke of Edinburgh: When asked if he would like to visit the Soviet Union.

The Duke of Edinburgh telling jokes at the Royal Windsor Horse Show.
11th May, 2006

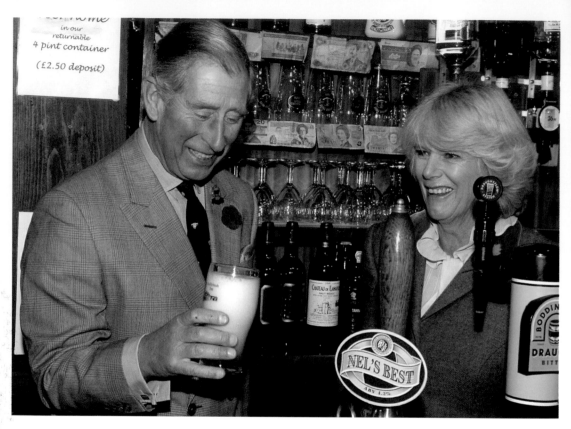

Prince Charles and Camilla, Duchess of Cornwall sample the wares of the Holly Bush Inn
at Greenhaugh, Northumberland during a tour of the North East.
9th November, 2006

"I really need a gin and tonic."

Camilla, Duchess of Cornwall: After half an hour of tea and small talk when Prince William
met his father's partner for the first time in July, 1998.

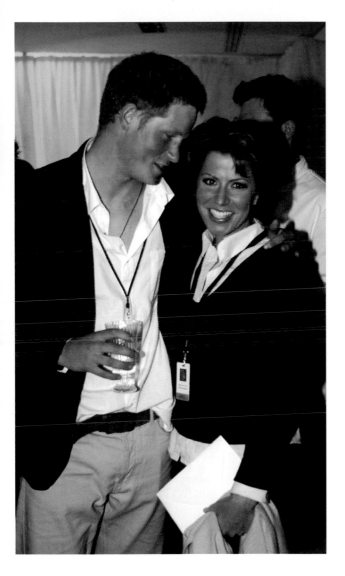

"I am very sorry if I caused any offence or embarrassment to anyone – it was a poor choice of costume and I apologise."

Prince Harry: His apology after a tabloid newspaper photo showed him wearing a Nazi German soldier's uniform at a fancy-dress party in January, 2005.

Prince Harry with BBC newsreader Natasha Kaplinsky at a reception following the Concert for Diana, a music festival held at the old Wembley Stadium to commemorate the tenth anniversary of Princess Diana's death.
1st July, 2007

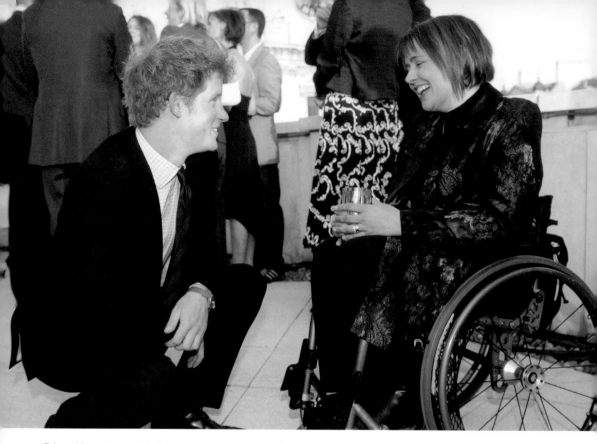

Prince Harry chats with Paralympic athlete Dame Tanni Grey-Thompson during a reception before the City Salute event at St Paul's Cathedral, London to raise funds for injured servicemen and women.
7th May, 2008

"It's very nice to be a sort of normal person for once; I think it's about as normal as I'm going to get."

Prince Harry: Referring to his time in the Army, as quoted in *The Washington Post*,
29th February, 2008

Prince William and former Guardsman Simon Weston, who was badly burned during the Falklands War, chat at the reception prior to London's City Salute charitable event for injured servicemen and women.
7th May, 2008

"All these questions about do you want to be king? It's not a question of wanting to be, it's something I was born into and it's my duty... Wanting is not the right word. But those stories about me not wanting to be King are all wrong."

Prince William.

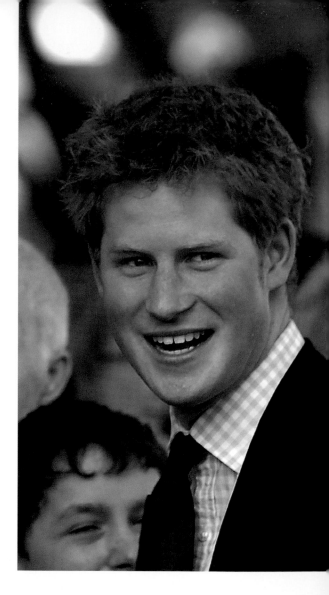

"I want to carry on the things that she didn't quite finish. I have always wanted to, but was too young."

Prince Harry: About continuing the work of his mother, Princess Diana.

Prince Harry visits the University Hospital of Wales, Cardiff to meet staff working for Dolen Cymru, a charity that promotes links between health organisations, schools, villages and districts in Wales and the African nation of Lesotho. 5th June, 2008.

"To get the best results, you must talk to your vegetables."

Prince Charles.

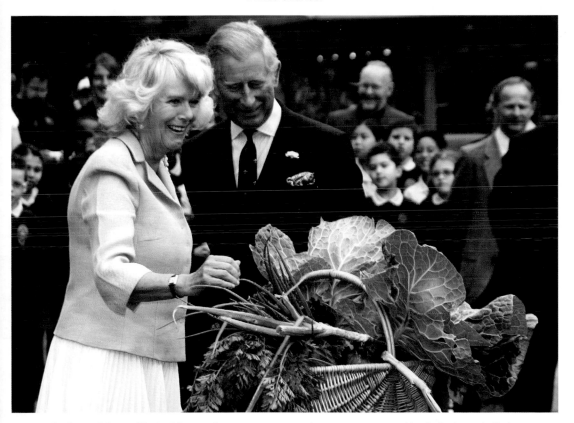

During a visit to a Dig for Victory allotment to promote home-grown vegetables in St James's Park, London, the Duchess of Cornwall was presented with a giant cabbage to celebrate her 61st birthday. 17th July, 2008.

"You are a pest, by the very nature of that camera in your hand."

Princess Anne.

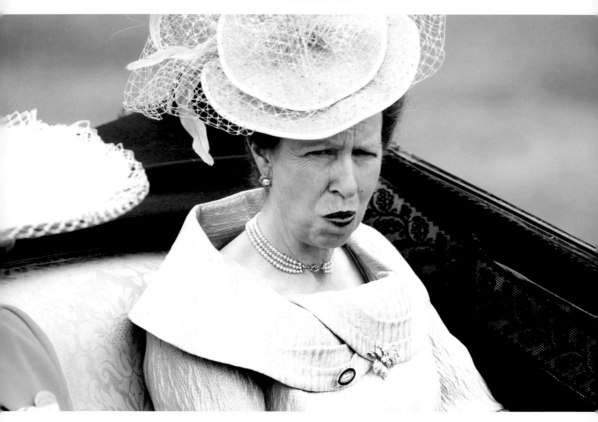

Princess Anne at Royal Ascot.
2008

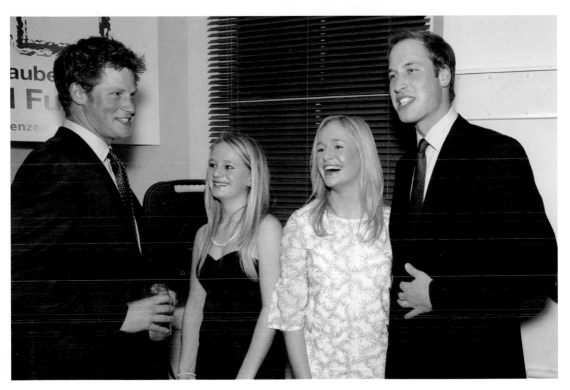

Prince William and Prince Harry with Olivia and Jessica Yeandle at the Troubadour Club in London, where they joined friends and family of their childhood friend, Henry van Straubenzee, to announce that they would become figureheads for the Henry van Straubenzee Memorial Fund, a charity that supports schools in Uganda.
9th January, 2009

"Most of them I can't call him in front of you. You know, a bit rude."

Prince William: On the nicknames he calls Prince Harry, during an interview with American television journalist Matt Lauer, 23rd June, 2007.

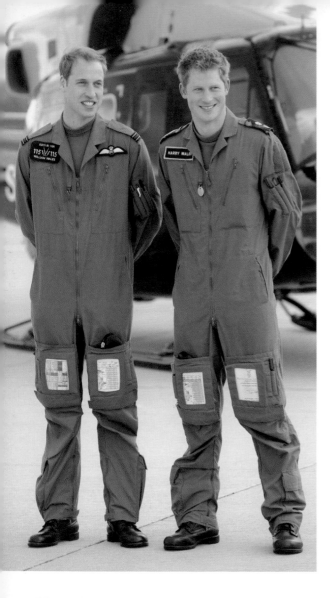

"He's definitely the more intelligent one of the two of us."

Prince Harry: On his brother,
Prince William, during an
interview with American
television journalist Matt Lauer,
23rd June, 2007.

Princes William and Harry
during helicopter training at RAF
Shawbury, Shropshire.
18th June, 2009

"I am and always will be an HRH. But out of personal choice, I like to be called William because that is my name and I want people to call me William — for now."

Prince William.

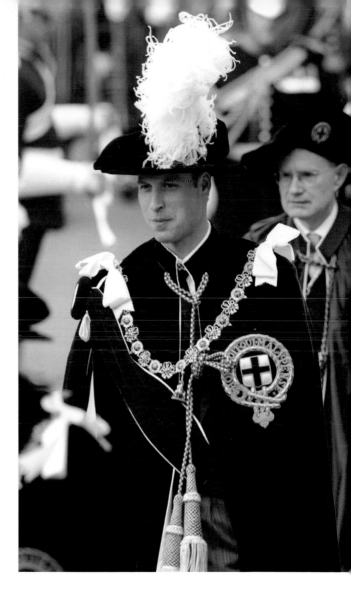

Dressed in a blue velvet robe and hat adorned with a striking ostrich feather plume, Prince William takes part in the annual Order of the Garter Service at Windsor Castle. The ancient chivalrous order was created by Edward III in 1348.
14th June, 2010

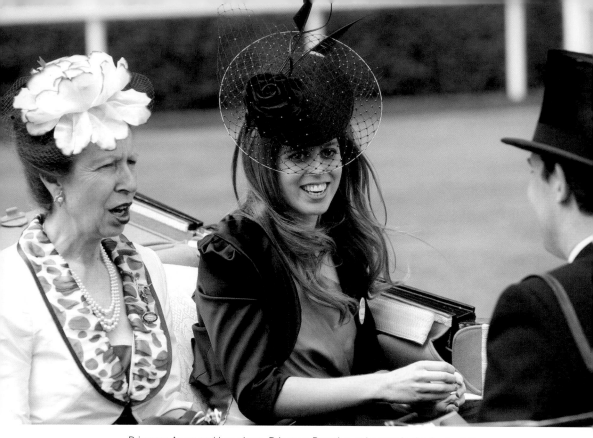

Princess Anne and her niece, Princess Beatrice, take part in the Ladies' Day
parade at Royal Ascot.
17th June, 2010

"I didn't like netball... I used to get wolf-whistles because of my short skirts."

Princess Anne.

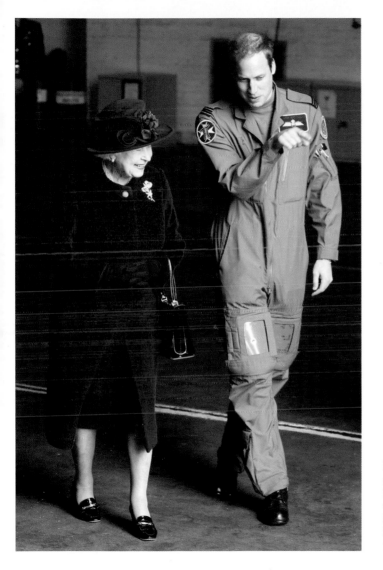

"I've had lots of kids come up and ask for my autograph; I've had a grandmother stop me and ask me if I know a good place to buy underwear."

Prince William.

Prince William with his grandmother, Queen Elizabeth II, at RAF Valley on Anglesey, where he was learning to fly Sea King search-and-rescue helicopters.
1st April, 2011

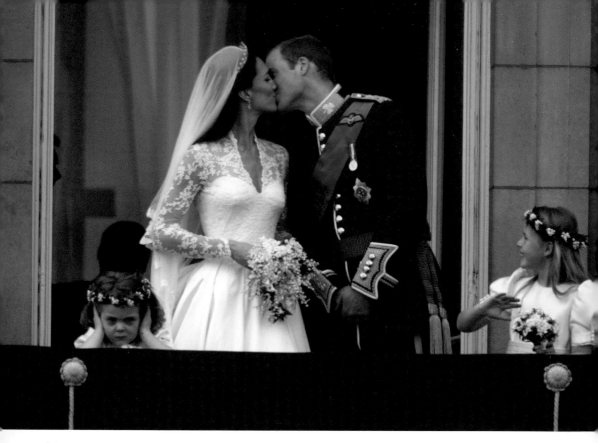

Prince William and his bride, Catherine Middleton, the Duke and Duchess of Cambridge, kiss on the balcony of Buckingham Palace, joined by bridesmaids Grace van Cutsem (L) and Margarita Armstrong-Jones.
29th April, 2011

"The whole thing!"

When asked what elements of his impending wedding day were giving him sleepless nights.

"We're very lucky. You know, we have lots of things that we are very fortunate to have. You know, we have a house, you know? We have, you know, all these sort of nice things around us. And so, you know, we're grateful for that because so many people don't have that. We have, you know, relative stability and stuff like that. And, you know, lots of things that, you know, everyone would, you know, love to have."

Prince William: Responding to the question, "What's the coolest thing about being a prince?" during an interview with American television journalist Matt Lauer, 23rd June, 2007.

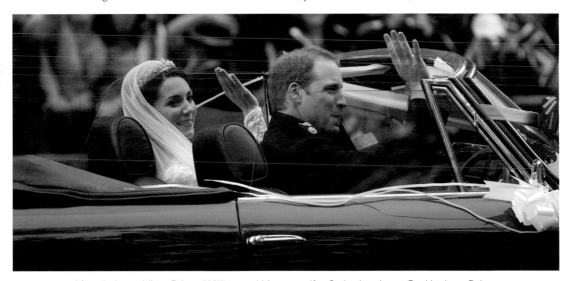

After their wedding, Prince William and his new wife, Catherine, leave Buckingham Palace for the short drive to Clarence House.
29th April, 2011

Queen Elizabeth II and Prince Philip, Duke of Edinburgh acknowledge the crowds as they arrive at Buckingham Palace after the wedding of Prince William and Catherine Middleton.
29th April, 2011

"You can take it from me, the Queen has the quality of tolerance in abundance."

Duke of Edinburgh: On marriage, 1997.

"People say to me, 'Would you like to swap your life with me for 24 hours? Your life must be very strange.' But, of course, I have not experienced any other life. It's not strange to me."

Prince Andrew.

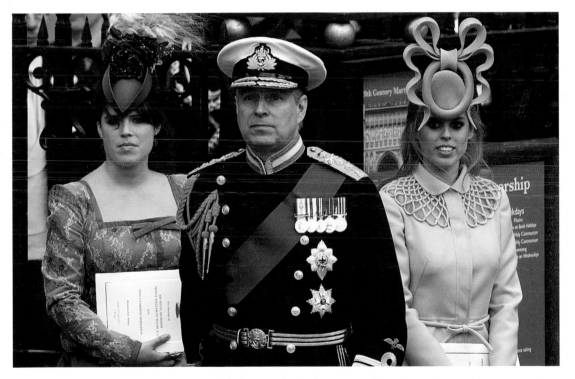

Prince Andrew, Duke of York with his daughters, Princesses Eugenie (L) and Beatrice, make a striking group as they leave Westminster Abbey after the wedding of Prince William and Catherine Middleton.
29th April, 2011

"They have overcome Becher's Brook and The Chair and all kinds of other obstacles. They have come through, and I'm very proud and wish them well."

Queen Elizabeth II: On Prince Charles' marriage to Camilla Parker Bowles.

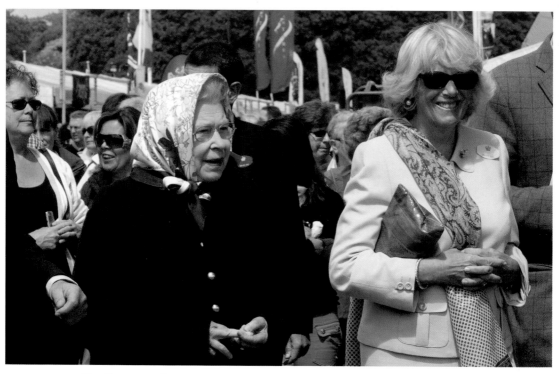

The Queen and Camilla, Duchess of Cornwall tour the Royal Windsor Horse Show.
12th May, 2011

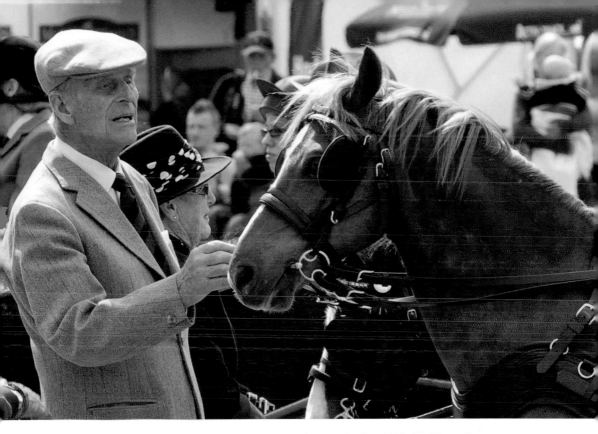

Prince Philip, Duke of Edinburgh greets a participant at the Royal Windsor Horse Show.
12th May, 2011

"And what exotic part of the world do you come from?"

Duke of Edinburgh: To black politician Lord Taylor of Warwick, 1999

Queen Elizabeth II and the Duke of Edinburgh show US President Barack Obama and his wife, Michelle, a variety of items relating to Royal visits to the USA at Buckingham Palace. One item was a letter from the Queen's late mother in which she discussed a hot dog she had eaten during her visit.
24th May, 2011

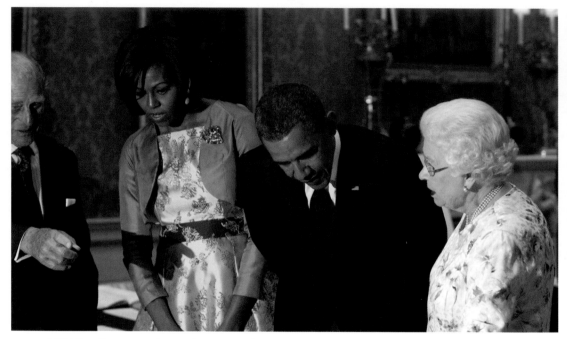

"We lost the American colonies because we lacked the statesmanship to know the right time and the manner of yielding what is impossible to keep."

Queen Elizabeth II.

"Be neither too remote nor too familiar."

Prince Charles.

Prince Charles jokes with a member of staff after opening the Marie Curie Hospice in Springburn, Scotland.
1st June, 2011

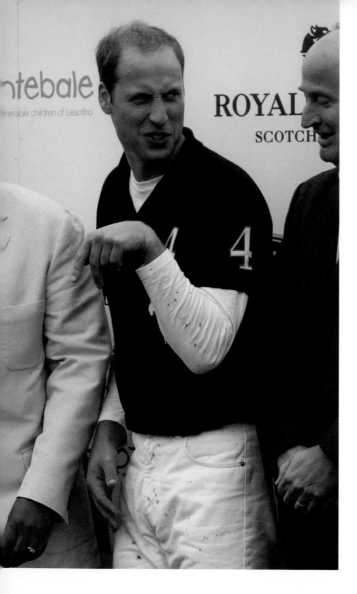

> **"I'm always open for people saying I'm wrong because most of the time I am."**
>
> Prince William.

Prince William after taking part in The Sentebale Polo Cup at Coworth Park, Windsor. He and his brother, Prince Harry, had captained opposing teams in the charity match in aid the poor of Lesotho.
12th June, 2011

During a Royal visit with the Queen to the North East, the Duke of Edinburgh meets pupils from Northumberland Church of England Academy at Alnwick Youth Hostel.
22nd June, 2011

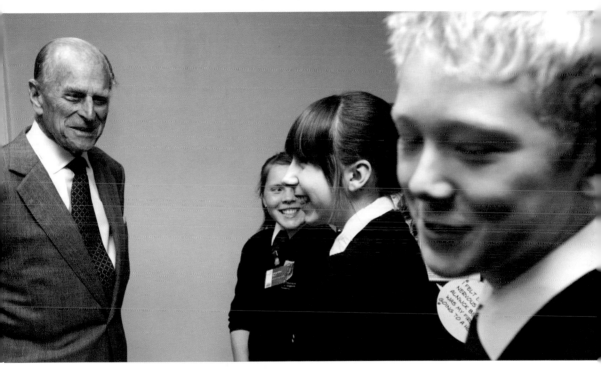

"Do you still throw spears at each other?"

Duke of Edinburgh: Said to an indigenous Australian
businessman, as quoted in 'Prince Philip's spear gaffe', BBC
News, 1st March, 2002.

The publishers gratefully acknowledge Mirrorpix, from whose extensive archives the photographs in this book have been selected.

AMMONITE
PRESS